Amphoto Guide to
Lenses

Amphoto Guide to
Lenses

Keith Bancroft

AMPHOTO
American Photographic Book Publishing
An Imprint of Watson-Guptill Publications
New York, New York

Cover photograph courtesy of Canon USA, Inc.

Copyright© **1981** by Keith Bancroft. First published 1981 in New York, New York by American Photographic Book Publishing: an imprint of Watson-Guptill Publications, a division of Billboard Publications, Inc., 1515 Broadway, New York, N.Y. 10036

Library of Congress Cataloging in Publication Data

Bancroft, Keith, 1922—

 Amphoto Guide to Lenses
 (Amphoto Guide to series)
 Includes index.

 1. Lenses, Photographic. I. Title. II. Title: Lenses.

Tr270.B33 771.3'52 80-25625

ISBN 0-8174-3528-X (hardbound)
ISBN 0-8174-3527-1 (softbound)

Manufactured in the United States of America

10 9 8 7 6 5 4 3 2 1

OTHER BOOKS IN THE AMPHOTO GUIDE SERIES

Contents

Introduction

What is a lens—just a piece of glass? Sometimes. But it's usually a lot more. A lens can be anything from a piece of plastic to an intricate arrangement of many glass elements. It has only one important characteristic—the ability to control light rays.

While it may create a recognizable image, a pinhole is optically too rudimentary to exert much influence over that image. On the other hand, an elaborate series of glass components (all of which are carefully aligned and centered in a precision metal housing) provides great accuracy and flexibility in the manipulation of light.

Is a complex lens in an ingenious mount always the best choice for your photography? That depends upon several factors. For example: What kind of picture situations will you be involved in? Does the quality of your camera justify a super lens? Do you have enough real interest in photography to learn the proper use of a complicated optical device? And will potential improvement in picture quality be worth the added expense? These are questions you will be better able to answer as you read this book.

While it's convenient and ego-satisfying to own the latest, greatest lenses, it's by no means necessary. A casual look at some of the outstanding photographs of the past should convince anyone that the simpler optics of yesteryear were able to produce pictures that many of us cannot easily duplicate, even today. In photography, as in other crafts, it's the skill of people using appropriate equipment which produces outstanding results, not the equipment itself.

However, modern lenses are fascinating and beautiful, as well as being superb photographic tools. Serious camera owners want to know more about lenses, since most of us have secret plans to buy "that next one" as soon as we can afford it.

To that end, let's start our investigation with a little background, after which we'll look into some important properties of photographic lenses. Then we'll

examine various kinds of modern optics, exploring the ways in which each type of lens can help us take better, more diversified pictures. A new lens is not guaranteed to improve a photographer's skill, but it's certain to increase his or her pleasure.

It's assumed that most readers own 35 mm cameras and are primarily interested in lenses for that format. Therefore, unless specific reference is made to cameras of other sizes, you may conclude that any lens being discussed is meant for the popular 35 mm picture-taker.

1

A Bit of History

THE CAMERA OBSCURA

In the mid-1500's, almost three hundred years before photography became practical, Daniel Barbaro, elaborating on the experiments of J. Cardano, tested a novel idea and was delighted with the results. He took one lens from the eyeglasses of a farsighted old man, enlarged a small hole in his wall, and inserted the piece of glass.

No, he wasn't out of his mind. He was merely trying to improve the image formed by his huge camera obscura, an entire room in which people gathered to watch a shadowy inverted scene on a wall opposite the tiny opening. Light rays from the outside (traveling in straight lines) crossed as they passed through the hole and formed an upside-down and reversed picture of the exterior view. The simple positive lens, which the nobleman had substituted for the conventional pinhole, not only sharpened up the image but brightened it enormously, for the aperture filled by the lens was much larger than the pinhole had been.

Although the camera obscura had a history that extended back for many centuries, this and similar experiments occurring about the same time were a sudden step forward. They laid the groundwork for the development of our modern lenses and cameras.

About 1600, Johann Kepler, a distinguished astronomer, began to use the camera obscura for solar observations. He took a positive (convex) lens element and placed a negative (concave) one at a suitable distance behind it, producing an enlarged image. (This is the principle of the modern telephoto lens.) Shortly after-

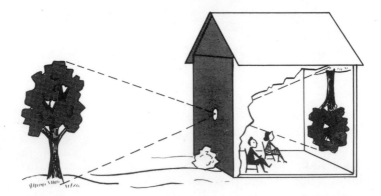

One form of camera obscura allowed a whole roomful of people to experience the reproduction of an outside scene.

ward the telescope was introduced, but astronomers doing solar studies continued to make use of Kepler's device—for blindness would have been the result of using a telescope to look directly at the sun.

Then, as camera obscuras became more diversified, ranging from the original room-size down to portable boxes anyone could easily carry, lenses were increasingly employed. By the 1830's, when the invention of sensitized materials by Niepce and Daguerre made photography possible, simple meniscus (eyeglass) lenses were already in common use to form images that could be traced, or copied by artists, or merely looked at for enjoyment.

However, even though lenses at the time were far more efficient than the pinhole, they still left much to be desired photographically. They produced distorted, fuzzy, and very dim images by today's standards, so the slow process of developing better optics to match con-

stantly improving sensitized materials was begun. Exposure times were to decrease gradually from minutes to seconds, and finally to fractions of a second.

THE LANDSCAPE LENS

In 1812, a number of years before the introduction of photography, William H. Wollaston, an English physicist, invented the first lens that offered a solution to the problem of distortion. He had observed that while the central portion of the image formed by a simple meniscus lens was acceptably sharp, the edges were blurry and unclear. He reasoned that light rays passing through the outer parts of the lens were causing the distortion, so he simply blocked them off with a "stop," a thin piece of metal with a hole in the middle.

But the hole in the stop could be much larger than a pinhole, because the lens helped to form the image. Wollaston had found a way to use the best part of the lens and reject the rest. An additional benefit was increased depth of field; that is, a greater front-to-back distance in the scene where everything was reasonably well in focus (see chapter 3).

This combination of a glass element and a fixed diaphragm, or stop, became known as the landscape lens. It was originally intended for the camera obscura, but when sensitized materials were introduced some years later, photographers made use of it immediately. Since that time, and until quite recently, this lens has been used extensively in the simplest of box cameras.

However, even though it was a distinct improvement over the pinhole, the landscape lens suffered from several defects that could be corrected only by adding more lens elements. The aberrations (defects) inherent in this type of lens are partly the result of different colors coming to a focus at different distances (chromatic aberration) and creating different-sized images in each of the colors (lateral, or transverse, chromatic aberration). There is also distortion of the kind which causes a square

13

Wollaston's landscape lens used a metal stop to improve the image quality of a simple meniscus lens.

object to be reproduced as a barrel shape or pincushion shape. And, thrown in for good measure, are spherical aberration and astigmatism.

C. Chevalier of France set out to eliminate some of these defects. At first, he took an already existing 16-inch telescope objective (lens) about 3½ inches (90mm) in diameter and used it in reverse with an $f/17$ metal stop situated approximately three inches out in front of it. This was the lens arrangement on the first Daguerre

Chevalier's achromatic lens retained the stop devised by Wollaston, but further enhanced image quality by employing two elements and cementing them together.

cameras. But, within a year or two, Chevalier went back to the Wollaston meniscus lens. He added another element, cemented the two together, and corrected most of the chromatic (color) difficulties. This so-called French (or *achromatic*) landscape lens became standard on the better grades of box cameras until about 1930.

PORTRAIT BY PETZVAL

The Chevalier achromatic lens was a large improvement in terms of definition, but it was still very slow—as were all lenses then available. When any of them were used in conjunction with the newly invented but equally slow sensitized materials of the day, exposures often ran to thirty minutes. Portraiture was impractical, for people were unable to hold still for that long. For a few years, photographers had to be largely content with inanimate subject matter.

The early lenses, such as those used by Daguerre in France and W. H. F. Talbot in England, were slow and imperfect. They were used in cameras like the ones shown here. (Reproductions of the Daguerre and Talbot cameras by Gerald Smith; from the Greer H. Lyle Collection.)

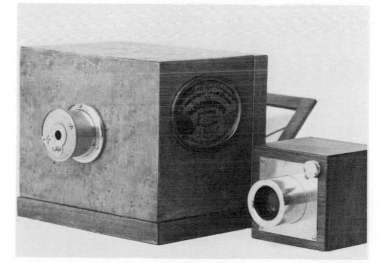

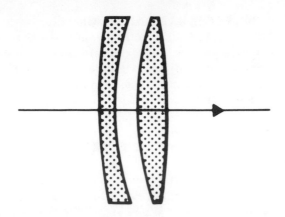

The Petzval portrait lens broke through many optical design barriers. It was both sharp and "fast" enough to allow practical photography of living subjects.

Because of the pressing need, Josef Max Petzval, a professor of mathematics at the University of Vienna, undertook the design of a new faster lens, one which would be practical for living subjects. He used two modified telescope objectives, widely spaced, each being achromatic and largely corrected for spherical aberration.

In 1841 he presented his new portrait lens to the world. It had (for that time) an astonishing speed of $f/3.6$, letting in about sixteen times as much light as the Chevalier achromat. But there was a price to pay. Its definition, although sharp and clear-cut on the lens axis, fell off rapidly beyond a narrow angle of view, due to astigmatism and field curvature. Fortunately, however, the lack of critical focus around the edges of a photographic portrait is not a serious drawback (in fact, it's usually desirable), so he had accomplished his purpose. In addition, because of its twin characteristics of relatively high speed and crisp central definition, the Petzval lens, with some modification, has been used with excellent results for motion picture photography and projection.

ACCELERATED PROGRESS

Further improvements came quickly. In the 1860's the symmetrical principle was discovered. It was found that if an element or group of elements on one side of the stop, or diaphragm, was symmetrically duplicated on the opposite side, many lens defects conveniently and automatically canceled out. Distortion, coma, and lateral color problems were so dramatically reduced by this method that symmetry in lenses became an almost universal rule for about fifty years.

Then, in 1886, barium glass was introduced. Until that time, only flint and crown glasses had been available for photographic use. But now, with a new material having a different refractive capability, lens designers had three weapons with which to attack lens aberrations. Very soon afterward, a four-element lens appeared which reduced astigmatism to near zero by using the new barium glass in one of its components. It was the celebrated anastigmat lens, which remained a very popular type for a considerable length of time.

Following this breakthrough, other designers combined the advantages of the anastigmat with some of the

Symmetrical lenses automatically cancel out many lens defects.

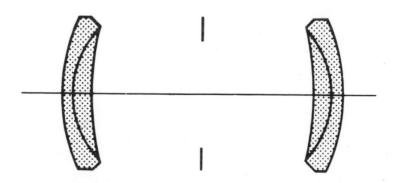

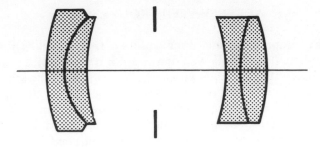

The Zeiss Protar was the first anastigmat lens ever developed.

proven symmetrical formulas, further reducing many troublesome aberrations. Lenses were still somewhat slow, but their definition had increased tremendously.

Up to this point, lens elements had usually been cemented together in doublets or triplets, at least when they were on the same side of the diaphragm. But now, designers began experimenting with air spaces between some or all of the various components. This changed the optical properties of a lens, allowing greater speed (up to f/3.5) while necessitating only a slight reduction in the angle of view. Lenses of this type are in general use today.

The Zeiss Tessar was one of many lenses to use air spaces as optical elements to improve lens speed while retaining high image quality.

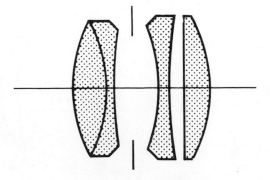

Well before the turn of the century, lens advances made commercial portraiture practical. This photograph was made after 1900.

By 1900, more elements were being incorporated into camera optics, often five or six. Aberrations were well under control, but additional components were needed to maintain that control while increasing speed and covering power.

In 1924, the Leica camera introduced modern 35 mm photography to the world and spurred further developments in lens technology. Normal-angle lenses were soon produced with apertures of $f/2$ or even $f/1.5$, while wide-angle lenses with a modest $f/6.3$ capability became commonplace. Designs of more complexity, diversity, and specialization followed rapidly.

Early limitations had forced lens makers to stay with normal-angle or narrow-angle types. A so-called normal lens is one in which the focal length (the distance from the optical center of the lens to the point where it focuses on the film at infinity) is approximately equal to the diagonal measure of the film format. A narrow-angle (or long-focus) lens has a somewhat longer focal length, takes in less of the scene before it, and produces an enlarged image.

A long-focus lens acts (and often looks) much like a telescope, magnifying the subject and making it appear as though the distance between it and the camera is less than in reality. This can be a great help in some situations. But long-focus optics are usually heavy and bulky, and they're certainly at least as long physically as their focal lengths.

However, just before the turn of the century a new lens design, called the telephoto, was introduced. In comparison with a long-focus lens of the same magnifying power, the telephoto had only fifty or sixty percent of the physical length. Bulk and weight were reduced, and handling ease was greatly improved. But lens speed had to be kept at moderate levels or aberrations began degrading the image.

WIDE-ANGLE BREAKTHROUGH

Wide-angle optics evolved slowly, dependent upon the arrival of methods to ovecome various aberrations so that image quality could be maintained to the very edges

of the normal field of view, and then pushed even beyond that. This type of lens was and is of most benefit to landscape, architectural, and group portrait photographers. A wide-angle (or wide-field) lens can take in more of a scene than one of normal design. Instead of moving back to cover a larger area, a photographer can accom-

Narrow-angle lenses (of which the telephoto is one type) magnify the image and allow practical photography of otherwise unapproachable subjects.

plish almost the same purpose with a wider lens (but perspective will be different—see chapter 3). In close quarters, where moving back is impossible, a wide-angle lens is the only answer (see chapter 6).

As originally used on a view camera or rangefinder camera, the wide-angle lens performed well and posed no problems. It could be mounted as close to the film as its

A wide-angle lens can take in more of any scene, like this park, without the photographer's having to move back.

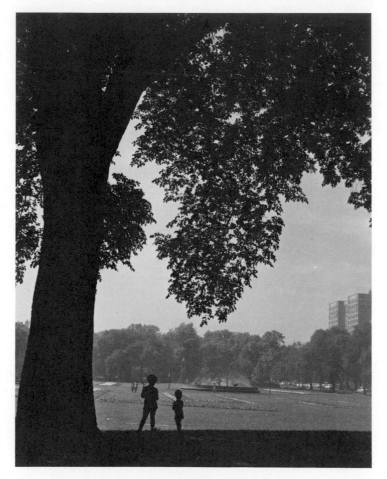

short focal length required. But trouble developed when an attempt was made to mate it with a single-lens reflex (SLR) camera—it interfered with mirror action. If the mirror was locked up out of the way, a wide-angle lens could be positioned close to the film, but then a photographer wasn't able to use the normal reflex viewing system. Or, if he did choose to utilize the swinging mirror, there was no room to mount the lens close enough to the film so that it could be focused at infinity.

This was the dilemma that faced many cameramen until the introduction (about 1950) of the reversed telephoto (retrofocus) design. By means of clever lens element placement, the retrofocus wide-angle is made to perform optically as though it were a conventional wide-angle mounted as close to the film plane as its focal length calls for. However, it is physically a greater distance away, so that the mirror of a single-lens reflex camera has enough room to clear it.

MODERN DESIGNS

Increased experience, expanded knowledge, and a variety of specialized glasses—all the result of a hundred or more years of experimentation—eventually enabled optical firms to introduce an even more startling design

By the re-positioning of some of its elements, the zoom lens makes possible rapid and precise changes in focal length.

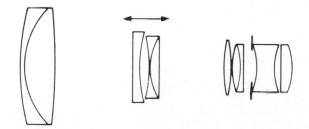

the zoom lens (see chapter 7). Here, in one package, was a lens that could change its angle of view and its image magnification at the whim of the photographer, while maintaining accurate focus throughout.

Zooms were available as early as 1932 for use on 16 mm motion-picture cameras; but, at that time, they couldn't compete with fixed-focal-length lenses in matters of resolution and freedom from aberrations. However, they improved rapidly, their evolution greatly accelerated by the needs of television production and the steadily increasing use of computers in lens development. Current models are often the equal of single-focal-length lenses in almost every respect and are becoming "standard" optics for many still photographers.

Another specialized design of recent years is the so-called macro lens (see chapter 8). This optic allows photography at a much closer range than would ordinarily be possible, both because of its ability to focus closer and its specific formulation, which enables it to produce its best results at short lens-to-subject distances.

Lens makers are presently outdoing themselves in the production of exotic and complex designs. The macro-zoom, presumably offering the best of two worlds, is proliferating. And optics that focus themselves have long ceased to amaze.

Where is the need for all these different lenses? What can they really do for us? These are questions that may be puzzling you at the moment, but the condition is only temporary. We'll find the answers as we investigate some of today's optical marvels in the chapters that follow.

2

The Physical Properties of Lenses

Although a lens, in the strictest sense, is simply a piece of glass shaped to control light rays, it most often consists of several related elements performing together for more efficiency. However, even a dozen or more high-quality glass components (elements) in a sophisticated combination can't do the job without help. They need to be aligned, centered, and spaced accurately, then maintained in that critical relationship.

This is why the metal housing called a lens barrel is vital. It surrounds the glass elements, preserves their orientation, and protects them from damage to a considerable degree. For these basic functions alone, a lens barrel deserves honor and praise.

But, with respect to most of today's complex mounts, that's only the beginning. Each provides a solid base to which further controls (shutter, iris diaphragm, focusing mechanism, etc.) are attached and made a part of the lens unit. The term *lens* is usually understood to include this entire package, the sum total of all the apparatus for manipulating light which enters the camera.

Not all lenses provide the same number or types of controls. The presence or absence of any one particular feature depends upon many factors. These may include the camera a lens is designed for (some of the controls may be on the camera body), the type of photography anticipated, the targeted market and price range, or just the whim of a manufacturer.

In this chapter we'll concentrate on the physical aspects of a complete lens package. An examination of

various mechanical features and their interrelationships will help us better understand (in chapter 3) the optical properties of a lens and how all factors work together to give a photographer the control he or she needs.

DIMENSIONS

In discussing the physical attributes of a lens, one convenient way of starting is to note the length, diameter, and weight. Among most lens manufacturers today, there seems to be a strong effort to outproduce the competition in shorter, thinner, and lighter optics, so these qualities figure prominently in lens ads.

Compactness in a lens *can* be important, of course. Smaller lenses allow you to stuff more of them into a camera case for traveling or hiking. And when using a powerful telephoto or zoom without a tripod, you'll find a lighter unit may save you a broken arm or two. Since weight and size, in themselves, offer no particular optical advantages, it's understandable that manufacturers will continue to pare them down as techniques for doing so are developed.

The length of a lens is usually expressed in millimeters (the metric method) rather than in inches (the English/American inch/pound system, where 1 inch = 25.4 millimeters), although both types of measurement are sometimes given in the same description. If a built-in hood is a feature of a given lens, length with and without the hood extended may be shown. Don't mistakenly confuse physical length with *focal length* (a strictly optical designation), for one can often be a great deal longer or shorter than the other.

The breadth or thickness of a lens is commonly referred to as the maximum outside diameter and, again, usually expressed in millimeters, the standard terminology for almost all lens description involving measurement. A lens barrel when viewed from the side, is not a smooth cylinder. Instead, its silhouette is a combination of peaks and valleys caused by the addition of control rings and flanges to the basic mount. It's logical, then, to regard the largest of these features as representing the diameter of the entire unit.

The weight of a lens is a conveniently straightforward measurement. But here, too, it may be expressed in either the inch/pound system or in metric—in ounces or grams (1 ounce = 28.3 grams). When comparing two lenses of equal focal length, you may find the weightier one generating more fatigue if you hand carry your equipment for any distance or shoot for extended periods of time. If several lenses are involved, differences in weight will be even more apparent.

However, there are many photographers who claim they can hold a heavier lens/camera combination steadier than a lighter one and thereby produce sharper hand-held pictures. It's a factor to be considered. Lighter doesn't necessarily mean better. Of course, if shooting from a tripod is your usual procedure, the weight of a lens should be of less importance.

OPTICAL CONSTRUCTION

Any attempt to sort lens features into neat little piles labeled *physical* and *optical* runs into immediate trouble when we turn to the actual pieces of glass and what they do. Obviously, we're now dealing with optical elements and their functions; and yet, when lenses are discussed or advertised, these aspects become an important part of their physical descriptions. Plainly, there's an overlapping area which takes in both physical *and* optical lens characteristics.

An example: maximum aperture. This is certainly an optical quality. But it's also a physical one, for the size of the largest diaphragm opening dictates one aspect of lens design. With this type of double standard in mind, let's look at some of the optical/physical features which are most often used to describe a particular lens or to distinguish one from another.

Lens Type

One of the simplest designations used to categorize large groups of lenses is type. While there are several divisions and subdivisions employed by manufacturers, advertisers, and photographers themselves, the most common

are *wide-angle* (taking in a large field of view), *telephoto* (bringing distant subjects much closer), *zoom* (varying focal length while maintaining sharp focus), *macro* (allowing extreme close-ups), and *normal* (providing an "average" angle of view and coming as standard equipment on most cameras). Also emerging from the computer rooms and factories of optical firms are exotic beasts known as *super-wides, fisheyes, wide-angle zooms, wide-to-tele zooms, short-to-long-tele zoom, macro-zooms,* and *mirror telephotos.* To further perplex and bewilder the novice photographer, other labels such as *speed lens, perspective-control lens, night lens, medical lens* and *portrait lens* are often used, although these special-purpose optics are of limited use to the average hobbyist (see chapter 8).

You'll note that as lens designers become increasingly inventive, the sharp distinctions between formerly separate types are blurred and blended. Lenses that can operate on both sides of "normal" because of a variable focal-length feature are called wide-to-tele zooms. Macros that are able to alter their focal lengths become macro-zooms. And otherwise normal zoom lenses that have macro capability as an additional feature are also known as macro-zooms. The former should probably be labeled *zoom-macros* (and possibly are by some manufacturers) and the latter *macro-zooms*, but as yet there are no firm standards.

It's the burgeoning number of lenses with changeable focal lengths which is creating such interesting and useful hybrids—and such confusion. It could well be that within a few years almost all camera lenses will be capable of zooming to suit the photographic situation at hand. But for now, we'll concentrate only on current models, exploring them in considerably more detail in following chapters.

Focal Length

The focal length of a lens is defined as the distance from its optical center (when focused at infinity) to the focal plane (the point where all the transmitted rays of light intersect and form an image). This measurement is usu-

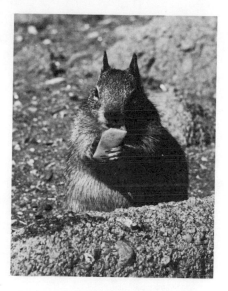

A telephoto lens, such as a 300 mm lens (used here on a 35 mm SLR), can capture a furry friend without disturbing his meal.

ally expressed in millimeters and permanently marked on the metal barrel. Since the focal plane is the only place where converging light rays create an image, it's the natural location for a camera's film—as well as a "focal-plane" shutter, if there isn't already a leaf shutter built into the lens. (Some camera/lens combinations have both.)

Along with lens type, focal length is the most widely used standard of lens description. It's easy enough to say a certain lens is a "tele," but just how powerful a telephoto is it? If the format is 35 mm, is the tele a moderate one of 90 to 135 millimeters, or is it a big gun in the 500 to 800 mm range? Only a focal-length designation will nail it down. However, that other vital piece of information, film size, is also needed to make the identification complete. A 90 mm lens is a short telephoto to the 35 mm camera buff, a normal lens for the medium format cameraman, but a wide-angle to the 4 × 5 devotee. Everything is relative.

In the past, focal length within a certain film format was usually a pretty good indication of image size, angle of view, weight, overall length, and even the maximum "speed" of a lens. But this is no longer true. There are now so many variations in lens types, formulas, and

A wide-angle lens is a great convenience when a large subject must be covered from a relatively close distance.

materials that a wide-angle can be longer and heavier than a normal lens, or two telephotos of the same focal length can be widely different in overall length and weight.

And this is just among single-focal-length lenses. When all the varieties of zooms are added in, it's sometimes hard to tell one lens from another without a scorecard. Zooms are not confined to one focal length but are infinitely variable within certain limits. They're usually marked, for example, f=45 mm–135 mm or 1:4/80–240 (giving the maximum aperture, f/4, as well as the focal length range).

In the next chapter, we'll go deeper into the optical ramifications of focal length and how they affect lens choice.

Aperture

The aperture of a lens is normally considered to mean its largest opening (or "stop"), thus denoting its "speed." To many hobbyists, the maximum aperture of a lens seems to be of considerable importance. They incorrectly believe that more "speed" somehow means more quality, although just the reverse is most often the case. A "fast"

lens can certainly mean more cost than a slower one, and therefore more snob appeal, but highest image quality is almost always the companion of a modest aperture. We'll get into the reasons why this is so in the next chapter.

To knowledgeable photographers, the opposite end of the aperture scale (the smallest stop) is also of interest, so lens advertisers frequently include both the maximum and minimum openings in their literature. After the type and focal length, aperture range (and especially the maximum stop) is generally the next most frequently used feature in lens identification.

The mechanism controlling the range of lens apertures is the iris diaphragm (except in some very old lenses, which often have a series of stops in the form of circular holes cut into a piece of metal). The modern diaphragm consists of several metal leaves working together like the iris of a human eye to provide a circular opening which can be varied in size. This apparatus is usually situated within the lens mount between glass elements and is regulated by a ring around the lens barrel. Detents (click-stops) and aperture numbers (f stops) on the ring or barrel allow a photographer to select just the size opening necessary to control exposure and/or depth of field (unless an automatic mechanism does it for him).

To set the record straight, speed in a lens does have its advantages. More light is admitted, so focusing is easier, and low-light shooting without flash becomes simpler. Many photographers want these advantages despite the higher expense . But many don't realize there are hidden costs as well—decreased depth of field and the possibility of lowered image quality when the lens is used wide open.

Angle of View

In describing the properties of a lens, angle of view is frequently mentioned in conjunction with focal length, for the two are often related. Angle of view is measured when a lens is focused at infinity and is expressed in degrees. For example: a typical "normal" 35 mm camera lens might be described as 50 mm in focal length with an f/1.4 maximum aperture and a 47-degree angle of view.

31

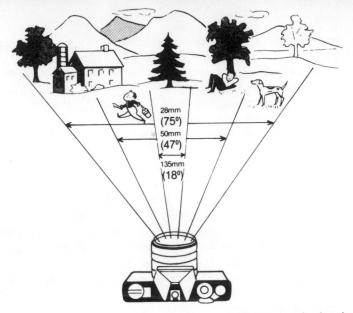

Three popular focal lengths for the 35 mm camera (28 mm, 50 mm, and 135 mm) cover three very useful angles of view.

With any given film format, the shorter the focal length of a lens the closer it will be to the plane of focus (when set at infinity) and the greater its angle of view. (In the case of retrofocus wide-angle lenses, the elements are not *physically* closer, but they behave *optically* as though they were.)

The covering power of a lens is not necessarily related to focal length but describes how large a film area a lens will cover with an image of acceptable quality. Its influence is behind the lens, while angle of view involves the "covering power" out in front—how much of a particular scene a lens will take in.

Wide-angle lenses, by definition, have a greater angle of view than normal lenses; whereas telephotos, as their focal lengths increase, cover smaller and smaller angles of view. Zoom lenses change angle of view along with focal length—wider angles with shorter focal lengths and narrower angles with longer.

32

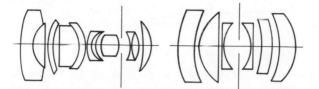

Two possible arrangements of lens components are 11 elements in 7 groups, and 6 elements in 6 groups.

Lens Elements

Because the number of elements a lens contains is a good barometer of its complexity and sophistication, and perhaps because of buyer interest, manufacturers frequently state this information in their advertising (often accompanied by a diagram representing a cutaway side view of the lens barrel and the placement of the lens elements within it). The data usually specifies the number of elements and groups, such as: 11 elements in 7 groups, or 6 elements in 6 groups.

An element is an individual piece of glass, while a group can be a single element standing alone or two different ones cemented together to form a unit. Thus, in the first example (11-7), there would have to be four groups of two elements each plus three standing alone in order to satisfy the relationship. However, in the second (6-6), it's clear that each of the six elements stands uncemented and isolated by air space from the others.

Unless a particular special-purpose lens has some or all of its elements made of an unusual substance (such as fluorite crystal or quartz), no data on lens composition is ordinarily given, even though modern lenses employ many exotic materials that were unknown in the past. These are generally referred to as rare earth glasses; but even they have their limitations, which is why special crystals are now sometimes used to overcome stubborn optical problems.

Neither the number of elements and their arrangement nor the composition of the glass in a lens is knowledge necessary to good photography. Focal length, aperture range, angle of view—these are all important to know, for they help in the picture-taking process. But lens element information is just frosting on the cake—nice to know but hardly vital. It's how a lens performs that's critical, not its internal structure.

Minimum Focusing Distance

Even though several accessories (extension tubes, bellows, positive supplementary lenses, and macro lenses) are available which allow close focusing on small subjects, many photographers dislike carrying extra equipment around with them. They prefer a basic lens with the ability to focus up close without resorting to extensive gadgetry.

In answer to this need, some lens designers in recent years have produced normal, wide-angle, telephoto, and zoom lenses that focus at shorter distances than were previously possible. One result has been more close-up photography by hobbyists. Another has been increased interest in minimum focusing distances, so this information is almost always included in the physical description of a new lens when it's advertised.

Every lens is designed with an optimum focusing point, one at which it exhibits the least evidence of aberrations and the best overall image quality. For general photography, this ideal point is understandably set at some distance from the camera in order to cover subjects like people, sporting events, and mountain scenery adequately.

Yet general-purpose lenses, designed to produce sharp results at long range, can also perform quite well at much closer distances. However, due to rapidly deteriorating image quality, the minimum focusing point is usually held to about ten times the focal length for normal lenses. Wide-angle optics can tolerate a smaller factor and focus proportionately closer, but longer lenses have more restrictions built in. Their near focusing distances are most often substantially more than ten focal lengths.

Therefore, when a lens designer furnishes a mount that allows focusing at distances appreciably closer than the above standards, something has to give. The nearer approach is made possible, to some degree, at the expense of image quality. (This does not hold true, of course, for macro lenses, which are computed to produce their best results at close quarters.) It's for this reason that any general-purpose lens used at its closest focusing point, or with close-up accessories, should be stopped down at least halfway in order to minimize the aberrations aggravated by close focusing.

As we learned earlier, stopping down takes advantage of a lens's best area, the central part. Consequently, the use of a medium-to-small stop is an especially important precaution in close-up work.

Lens Coating

If there were such a thing as a "perfect" lens, a ray of light could enter and pass through completely, with none of it reflected, scattered, or lost. Unfortunately, this ideal will probably never be realized, even though today's lens coating techniques have made large strides in that direction.

When a light ray hits the air-to-glass boundary of an uncoated lens, most of it passes through, but a small part (4 to 5 percent) is reflected back from the front surface. Of the light that continues on, a similar amount is again reflected from the rear surface of the same element. And another small portion is simply absorbed by the glass.

In a complex lens system of several elements, none of which has a modern antireflection coating, a great deal of the original light (as much as 70 percent!) never reaches the film to form the intended image. But the absorption and loss of a substantial amount of light energy is not the great problem. Even more serious is the image degradation which takes place because of all the rays that are reflected back and forth many times within and between lens elements, lowering image contrast and ending up on the film as flare and "ghosts".

Before the coating of lenses became an accepted practice, designers attacked this shortcoming by keeping

the number of elements small and cementing them together in pairs, whenever feasible, to further reduce the total of air-to-glass surfaces. Knowledgeable photographers did their bit by using effective lens hoods, avoiding bright objects and lights in the picture area, and stopping down whenever possible (which reduced many of the reflections but also further diminished the quantity of light energy reaching the film).

Light loss and flare worsen dramatically with each additional uncoated element in an optical design, so high-speed lenses, retrofocus wide-angles, and zooms were out of the question until a way could be found to increase light transmission through their many components. The discovery of lens coating opened the door for most of today's incredible optical marvels, bringing less flare, fewer ghosts, higher contrast, and more usable light delivered to the film surface.

Surprisingly, the benefits of coating a lens had been known for years before the practice became almost universal. It began in England at the turn of the century when a lens manufacturer found that a "bloom" or tarnish which had formed on some of his lenses actually improved image contrast. After a time, lenses were purposely treated in order to gain this advantage.

Then, during World War II, two researchers at the University of California developed the current method of coating optics by depositing an extremely thin surface film of calcium or magnesium fluoride onto a lens (or group of lenses) in a vacuum chamber. When the thickness of the layer was just right, incoming light being reflected from the lower surface of the coating back to the upper surface interfered with the reflected part of new incoming light. This cancelled out much of the reflection and effectively increased transmission. By this means, the light loss from each air-to-glass surface was brought down to about one percent from the four or five percent of an untreated lens. After that, coating became practical and widespread.

That was "single" coating. Today, most lens makers employ multicoating techniques. Since no one coating material or thickness can handle all the various wavelengths of light, several ultrathin layers are laid down

individually. They produce a wide range of reflected rays which interfere with incoming light at several different wavelengths, and by doing so increase transmission over a wide spectral range. But multicoating techniques are critical and difficult, bringing new problems—not least of which is increased cost.

For this and other reasons, some manufacturers multicoat only part of their lens output. Others multicoat only some surfaces of some lenses. Still others ignore it completely. True multicoating involves a minimum of four layers and perhaps as many as eleven. But many excellent optics have only two or three and yet compete quite favorably with their thicker-skinned cousins.

Single coating was a great advance over noncoating, but multicoating does not represent the same large jump forward. It gives some degree of additional help under special circumstances but seldom seems worth the extra expense unless a lens has an unusually large number of elements. Often, stopping a single-coated lens down a bit is just as effective as using a multicoated optic wide open.

Research continues, however, and techniques are improving steadily. Perhaps, one day, we'll see the lens with "perfect" light transmission.

LENS-MOUNT FEATURES

When lenses are advertised or described, certain mechanical features of the mount itself are often mentioned, for a camera does not live by optics alone. These adjuncts to the glass components are vital if a photographer is to have full control over the image-forming light. We'll consider them in their approximate descending order of importance.

The Diaphragm

The iris diaphragm in a lens is necessary for three reasons: to control the amount of light reaching the film during any given period of time, to regulate depth of field—the zone of acceptable sharpness extending both forward and back from the point of exact focus—and,

less important, to influence image quality. (More about these functions in chapter 3.)

As pointed out earlier, the first diaphragm was just a piece of metal with a hole in it that was placed ȯn either side of a single-element lens and used to block out light coming through its outer edges so as to minimize lens faults. Later, a series of such holes (each one a different diameter) was made in a rectangular or circular plate, which could then be inserted between lens elements and slid or rotated to bring various stops into the light path, giving photographers greater control over outer-edge aberrations and allowing them to select their stops based upon exposure and depth-of-field.

However, the mechanism in almost universal use now is the iris diaphragm. With it, an adjustable hole is formed by a number of thin metal blades (the more blades, the rounder the hole) which are mounted on a rotating ring and placed between elements at the midpoint of a lens. Typically, another ring on the outside of the mount controls the exact opening needed and is marked off in *f* stops. The various hole diameters pro-

Photographers were once confined to the stops predrilled in a metal plate or disc, but the modern iris diaphragm allows (within a specified range) an almost limitless number of lens openings.

vided by an iris diaphragm are still called *stops*—a hold-over from the early days.

When it was introduced, the iris diaphragm (with its wide-range, continuous adjustability) was a great boon to photographers in a hurry. Its manipulation was entirely by hand, but inventive minds soon contrived ways to make even the simple task of altering lens openings easier and faster.

The first advance was a manual pre-set diaphragm. Along with the normal diaphragm-setting ring was a second ring containing a mechanical stop and the *f*-number scale. After the working aperture was selected and set by means of the mechanical stop, the diaphragm control ring was turned to full open for focusing. Then a quick twist of the ring brought it back to the pre-set stop for exposure. For the first time, it wasn't necessary to watch when a change of stops was made. This type of pre-set arrangement is still being used, on some of the longer lenses.

The next step, logically, was to make the pre-set system semi-automatic. This was done by spring-loading the diaphragm control ring at full aperture. Then, when the shutter release was pressed, the spring quickly stopped the lens down to the preselected opening just before the shutter was activated. This expedited picture-taking considerably at the critical moment when the subject was "just right." Of course, the spring had to be retensioned after each shot, but this was a small price to pay for what was otherwise a great convenience.

Today we have fully automatic diaphragms in which tensioning is coupled with the film-advance lever. In some, the aperture must be pre-selected and set on a ring. In others, a built-in exposure meter and attendant linkage do the work. On most modern 35 mm single-lens reflexes (SLRs) with instant-return mirrors, the diaphragm also opens fully again after an exposure has been made.

All these developments have led to the most recent phenomenon: 35 mm cameras with auto-winders or motor drives. Now photographers can use up film very rapidly without having to pause between exposures to make adjustments—or to think.

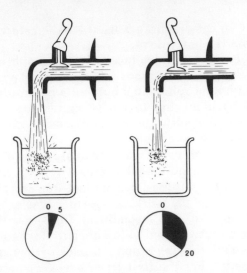

If a given flow of water will fill a container in five seconds, a flow of one-fourth as great will take four times as long (twenty seconds) to accomplish the same result. The same principle governs the relationship between f stops and shutter speeds in photographic exposures.

The Shutter

While the diaphragm performs three functions, the shutter offers just one—the slicing of time into precise little pieces. After an exposure level has been determined (based upon light intensity, subject brightness, and the film/developer combination being used), the shutter and diaphragm work together to regulate the quantity of light reaching the film.

The interaction of these two basic exposure controls is similar to the process of filling a water bucket from a tap. The amount of liquid streaming from a tap is like the amount of light passing through the diaphragm of a lens, while the length of time a tap is left running is analogous to the length of time a shutter is open. A tap turned on full force will fill a bucket very quickly, just as a wide-open lens diaphragm will allow picture taking at fast shutter speeds. On the other hand, if just a trickle of water flows into a bucket, it will take much longer to fill it. In the same way, if a lens is stopped down to a small

40

opening, more time (a slower shutter speed) will be needed for the light to build up and register with enough density on the film.

In the early days, when optics were slow and emulsions even slower, the simple act of removing and then replacing a lens cap served as an effective shutter—especially since exposure times often ran to several minutes. But as larger-aperture lenses and more sensitive films were evolved, a mechanical device of some kind was needed to control the much shorter exposure times.

Many approaches were tried, some with lasting success but most with only fleeting popularity. There were roller-blind shutters, guillotine shutters, flap shutters, eyelid, rotary, and everset sector shutters. The last mentioned is still used in some inexpensive cameras, but the majority are now obsolete museum curiosities.

However, two worthy designs have become today's favorites: the focal-plane shutter and the leaf shutter. The focal-plane shutter, as its name implies, must be fitted inside the camera as close to the film surface as practical. It may be either the common double-curtain variety or a more recent type using movable parallel metal blades.

With such a mechanism being part of the camera body, designers can eliminate the shutter function from a lens, furnish it in barrel mount only, and thereby lower its cost. The shutter-speed dial, release button, and cable-release socket (whether speeds are determined manually or automatically) are all then located on the camera body. This arrangement has made the 35 mm camera, with interchangeable lenses, an affordable reality for millions of people.

On the other hand, leaf-type shutters are usually designed to be part of the lens itself. Typically, there is a ring of three to five thin metal blades which are pivoted at their outer edges so they can open and leave an unobstructed light path. When at rest, they are interleaved to form a completely closed "curtain" between the lens components. When the shutter release is pressed, a spring-loaded ring causes the blades to swing out very quickly to the edge of the aperture, allowing light to pass through the lens.

41

Some designers of interchangeable-lens cameras, in order to avoid incorporating a shutter in every lens (which would escalate costs), position a leaf shutter in the camera body just behind the lens. This achieves economies but limits the range of lenses that can be used, because many wide-angles and telephotos cannot function properly under these restrictive conditions.

Therefore, for greatest flexibility, leaf-type (or "between-the-lens") shutters are more advantageously placed where you'd expect—*between the lens elements.* Equipping each interchangeable lens with its own shutter is more costly, but the benefits certainly offset the added expense. Good quality medium-format cameras in the 6 × 6 cm (centimeter) or 6 × 7 cm sizes are often constructed in this way.

Although the focal-plane shutter allows for less expensive lens interchangeability, the leaf shutter has one outstanding advantage, especially for professional photographers: It makes electronic flash synchronization possible at *all* shutter speeds—not just the 1/125 or 1/60 (or slower) provided by the focal-plane type. For studio work, synchro-sunlight fill lighting, and all situations where serious photographers must be sure of getting dependable results under unpredictable circumstances, the leaf shutter offers this huge advantage. Its top speed is generally not as high as that of the focal-plane, but its wide-ranging flash-synch abilities more than make up for that.

With a leaf shutter, the speeds are set by a movable ring on the lens barrel or internally by an automatic mechanism (in which case, the speed being used is visible in the viewfinder). In the past, several different sets of fractions were used to delineate shutter speeds, one very popular one being: 1, 1/2, 1/5, 1/10, 1/25, 1/50, 1/100, 1/250, and 1/500. But, obviously, this series is nonlinear; that is, the intervals are not all equally spaced. To overcome this defect, practically all modern shutters now use a different, even-spaced series so that each shutter speed is just half that of its slower neighbor or twice that of its faster one. The currently popular sequence runs: 1, 1/2, 1/4, 1/8, 1/15, 1/30, 1/60, 1/125, 1/250, and 1/500. Some shutters extend to 1/1000 or even 1/2000.

With many of today's automatic cameras having electronically controlled shutter speeds, a computer-like "brain" may select (and the shutter provide) 1/87, 1/312, or any other oddball slice of time according to information received from the built-in meter. It's somewhat unnerving to have so much control turned over to an unthinking integrated circuit, but it's also very convenient.

Although a leaf shutter built into a lens can often be released from a point on the lens mount itself (as frequently happens with large studio or view cameras), almost always some internal linkage is provided so that the shutter is both tripped and recocked from the camera body. With this arrangement, automatic double-exposure prevention is usually included.

Worth mentioning is another configuration called the "programmed" shutter, which permanently links the shutter and diaphragm functions. It's generally used in simplified automatic cameras. A built-in meter not only chooses the correct exposure (that is, determines the "exposure value" of the scene) but also picks an appropriate preselected shutter/diaphragm combination without the help (or knowledge!) of the photographer. A programmed shutter seriously limits the ability to control action or depth of field, but its automatic functioning is a great relief to those picture-takers who don't want to bother with burdensome technicalities.

Focusing Systems

When a photographic lens forms the image of an outside object on the film within a camera, the image will be sharp and clear only if the lens is positioned at one specific distance from the film plane. That distance is dependent upon two things: the focal length of the lens being used and how far away the object happens to be. Coordinating these two factors and finding the best lens-to-film distance is what is meant by focusing.

Many inexpensive "box" cameras have lenses which are factory set and cannot be moved. But these lenses have small apertures, so the resulting great depth of field allows them to be in reasonably good focus over a

range of about seven feet to infinity. As long as a photographer, using such a camera, doesn't approach the subject too closely, no focusing problem will occur. However, dimly lit scenes and fast action are out of the camera's reach unless flash is used.

Excluding this fixed-focus type, all cameras must have some method of adjusting the lens so that an object at almost any distance (usually from about ten times the focal length to infinity) can be brought into sharp focus. There are several ways of doing this, but they all share two requirements: any looseness or play within the lens mount must be eliminated, and the lens must always be held precisely parallel with the film plane.

The best and most obvious way to change the position of a lens is to move it as a unit. If a lens is mounted on a board which is in turn attached to the film-holding section of a camera by a bellows (as in press or view cameras), the method is simple. Rack-and-pinion focusing (a toothed gear engaging a toothed metal strip) makes it easy to move the lens board (or camera back) to many positions.

Focusing a twin-lens reflex camera is equally simple. Both the viewing and the taking lenses are mounted on the same board or panel and focus together, usually by means of rack and pinion or a pivoted lever. Sometimes the two lenses are set in round interlocking gears. Turning the viewing lens to focus also adjusts the taking lens.

Rack-and-pinion focusing is excellent when the camera and the lens movement are both relatively large. But for smaller cameras (such as 35 mm) with shorter focal length lenses, it won't do. A system offering much finer adjustments is needed. This is accomplished with a lens mount resembling two close-fitting tubes sliding one inside the other, one section supporting the lens and the other attached to the camera body. When an outer ring on the lens mount is turned, a helical screw moves the lens forward and back as a unit. By this means, a large rotary movement of the focusing ring produces only a relatively small in-or-out movement of the lens.

With macros and other close-focusing lenses for small cameras, a double helical arrangement is used. One

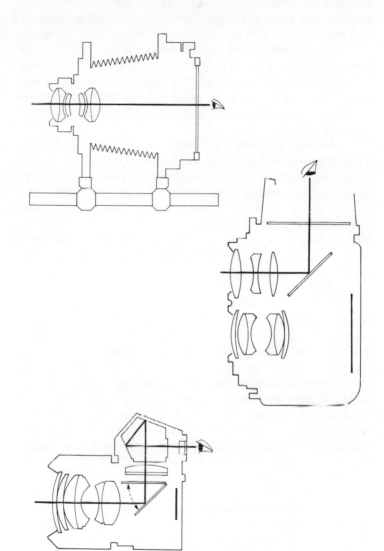

Cameras with direct ground-glass viewing (top) presents an upside-down and reversed image to the photographer. Simple reflex cameras (center) show an image right side up but still leave it laterally reversed (left to right). Cameras with pentaprisms (bottom) not only display an image upright, but correct it from side to side as well.

45

tube section unscrews first, then another takes over to increase the extension. In this way, the lens can be moved even farther from the firm plane and focused on a much nearer object.

Some inexpensive cameras use lenses with front-element focusing. In this system, the front element alone moves in and out, rotating on a helical screw while the rest of the lens remains stationary. Although this method is cheap and convenient, it has both optical and mechanical drawbacks.

No matter what mechanism is employed to adjust a lens, photographers must have some means of knowing when the focusing distance is correct. Studio and view cameras use direct ground-glass viewing to examine the image. Many medium-format and 35 mm cameras use reflex viewing, in which case the image is reflected off a mirror before reaching the viewing screen. Adding a pentaprism is a further refinement which allows the mirror-reflected image to be seen not only right-side up but also unreversed left-to-right and at eye level.

Other fine cameras, both 35 mm and press-type, employ separate optical viewfinders along with lens-coupled rangefinders to determine precise focus. This method is fast and accurate, and is especially valuable in dim light, but it has the drawback of not allowing the photographer to see the actual image formed by the lens. Using a separate finder results in parallax (a difference in viewpoint between the viewfinder and the lens) and causes difficulty in framing a scene without accessory equipment when very short or very long focal length lenses are used.

Most focusing systems employ a visual scale on the lens barrel or camera body to let the photographer know the approximate distance at which the lens is focused. The simplest, but least efficient, focusing method of all requires that the photographer guess the distance between the lens and the object to be pictured and move a ring or lever until this guess is set on the focusing scale, which in turn adjusts the lens (usually a front-element focusing type). Frequently, a depth-of-field scale is included as well, so that an intelligent combination of distance and f/stop can be chosen to insure that every-

46

thing of importance in a scene will be reasonably sharp.

Currently, automatic focusing systems are sometimes utilized to advantage. Automatic systems employ three different methods to set lens position: contrast comparison, infrared light ranging, and sonic ranging. In each case, a servo motor adjusts the lens until its point of sharpest focus is reached, at which time movement stops —unless (as with movie cameras) the subject distance continues to change. Motion-picture cameras benefit greatly from automatic focusing, because it allows you to follow action without concern about keeping a moving subject in focus manually. "Instant photography" cameras have always had the goal of making photography as simple and effortless as possible. With the addition of automatic focusing, that objective seems to have been reached.

Mounting Methods

There are two basic systems for attaching a lens to a camera body (either directly or by means of a lens board): screw-thread and bayonet. Each has advantages and disadvantages.

The screw-thread mount (in which the threaded end of a lens barrel screws snugly into a similarly threaded flange on a camera body) is the simplest and most obvious device for accomplishing the connection. Its advantages are reliability, freedom from adjustment problems, and easy interchangeability. A standardized thread pitch and a few standardized diameters make hundreds of lenses from various manufacturers available to photographers with screw-mount cameras. Consequently, many lower-cost substitutes for a camera manufacturer's own lens line can be used (as well as oddball designs the camera maker doesn't provide at any cost). The one big disadvantage is the time it takes to interchange lenses, rotating one several times to remove it and then going through a similar procedure to install another.

For this reason, bayonet mounts have now taken over in popularity, for the bayonet lens-mounting system shortens this process considerably. With it, a lens is lined

47

up with a dot or notch on the camera body, pushed into the lens opening until stopped by a flange, and then merely twisted a quarter turn or so until it locks into place. To remove it, a button or lever is pressed to release the lock, after which the insertion process is reversed. The saving of time and effort is the bayonet mount's greatest advantage. But offsetting this is a drastically limited choice of lenses with compatible hardware. Frequently, because bayonet mounts haven't been standardized like screw mounts, only the lenses specifically designed for a camera by its own manufacturer can be used. However, because we're living in an age when speed seems increasingly important, bayonet mounts are being supplied on more and more of today's lenses.

A variation on the bayonet is the breech-lock mount, a system that is identical in that it requires a lens to be lined up with and then inserted into the camera body. But then, instead of turning the entire lens until it locks into place, a movable flange on the lens barrel rotates until everything is tight and secure.

Another popular approach employs the so-called "T"-mount adaptor. A manufacturer using this device delivers all lenses with a standard mount but in barrels which are too short. However, when attached to the special adaptor, each lens becomes exactly the right length. A variety of these adaptors is provided, each for a different type of camera mount, allowing any one lens to fit a multitude of cameras just by choosing the correct accessory.

Important Extras

Other features sometimes included on a lens mount are a flash synchronization contact and switch, a depth-of-field preview button or lever, and a tripod socket—although any or all of these may be on the camera body instead. The flash connection may allow for any combination of M (regular flash bulbs), FP (focal-plane shutter bulbs), or X (electronic flash) synchronization. The preview button is handy for checking front-to-back focus at

any particular lens stop. And the built-in tripod socket is a necessity if the lens is heavy, for supporting it by a tripod-mounted camera body instead of by its own socket might put too much strain on the lens-to-camera mount and introduce unnecessary vibration besides.

SPECIAL EQUIPMENT

Many lenses intended for special-purpose usage provide unusual or sophisticated additional equipment such as: built-in filters (usually with wide-angles, where a front-mounted filter would cut into the field of view), built-in lens hood (a convenience), built-in deliberate spherical aberration (for soft-focus portraits), and scales showing lens extension, image-to-object size ratios, and exposure increase factors (important on macro lenses). Other extras may include controllable "floating" elements, aspheric (non-spherical-surfaced) elements, or elements made of unusual substances (all for the purpose of attaining sharper, faster, and lighter optics). One type of lens has a built-in electronic light-amplification system which allows picture-taking under almost totally dark conditions. Some lenses even come with special protective cases, making it easier to transport them safely (and providing a handy storage place for related filters and other accessories).

Finally, every lens has some combination of scales and control rings to handle its various mechanical functions. Most of them are not particularly special, and many have already been mentioned, but a summing up could be useful. Included may be scales and/or rings for the shutter, for the iris diaphragm (automatic, pre-set, or manual), for the depth-of-field indicator, for the zoom function, for focusing (or zoom and focus controls may be combined in one ring), for dial-in filters, for a floating element, for a breech-lock mount, or for the macro lens applications referred to in the last paragraph.

Control rings are sometimes narrow and sometimes wide. They can be made of ribbed plastic, knurled

49

metal, or a rubberized version of either. But, although all rings on the same mount (or on different mounts from the same manufacturer) are designed to work together harmoniously, lenses from two different makers will often have the same function (like focusing) operating in opposite directions. Under such conditions (after he's missed the prize shot of a lifetime, because he inadvertently turned the focus control the wrong way), a photographer has every right to feel frustrated and angry.

Lens-mount color (chrome or black) used to be an item of choice, but of late all lenses seem to be furnished in "professional" black. That's fine for night shooting or when a photographer wants to be unobtrusive, but all that black paint on cameras and lenses is pretty rough on film and fingers when the sun is blazing down from a mid-summer sky. Perhaps built-in refrigeration will be the next lens "extra."

3

The Optical Properties of Lenses

Now that we've looked at most of the physical features of a complete lens package, let's examine the optical characteristics in more detail. Some of the same ground (such as *focal length* and *aperture*) must be covered, but the emphasis will now be on optical rather than physical aspects. As mentioned previously, there's a great deal of overlapping between the two, so references to material in chapter 2 will occur from time to time. '

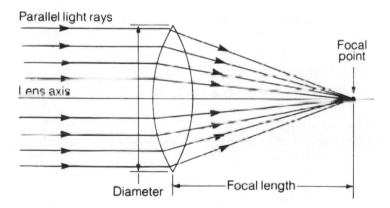

A lens controls light by bending incoming rays so that they converge at a common point and form a recognizable image.

Positive Lenses

plano-convex double convex converging meniscus

Negative Lenses

plano-concave double concave diverging meniscus

*Six basic types of lens elements are combined in various ways to
form even the most complex of modern lenses.*

LENS BASICS

What is a lens? As we already know, a lens, whether
simple or complex, is essentially a device for controlling
rays of light. It accomplishes this by bending the rays so
that they converge and form an image, which can then be
either directly observed or recorded on a sensitive emul-
sion (or on an electronic device, as with a video camera).
When light enters a lens, the greater density of the glass
(as compared with air) causes the rays to bend, because
the speed of light is lower in the denser medium.

The change of direction the light undergoes is
known as *refraction*. The measurement of this change is
known as the *index of refraction* and is one of the most
important characteristics of optical glass. The designer
of a complex lens system will use glasses of various

refractive indexes to help reduce weight and size and aberrations as much as possible.

Lens elements are identified by their shapes and their functions. Those that are thicker in the center than the edges cause light rays to converge and form real images. They're called *positive* lenses, the three basic types being known as plano-convex, double convex, and convex (or converging) meniscus. They have their counterparts in concave or *negative* lens elements—plano-concave, double concave, and concave (or diverging) meniscus—which are thinner in the center than the edges and cause light rays to spread rather than come together, making them incapable, by themselves, of forming images on flat surfaces. (It's easy to tell the difference between convex and concave if you remember that a *concave* lens curves *in*, like a cave goes *in* to the interior of the earth.)

However, a negative lens can produce a clear image for the eye, if not for the film. Used in a camera's optical viewfinder, for example, it furnishes a sharp, upright, non-reversed, and always-in-focus image, matching the view being projected onto the film by the positive camera lens. And in a taking lens, a negative component combined with a positive one offers a designer considerable control in manipulating the light reaching the film plane. The two types of elements are often paired, being either cemented together as a single group or separated by an air space (which acts as an additional element with its index of refraction being that of air).

In combination, when the converging power of a positive element is greater than the diverging power of a negative one, a real image is formed. The degree of converging power depends upon the relative strength of the positive element over the negative one and their spacing with respect to each other. In a complex lens design of several elements, the total strength of all the positive components must be greater than all the negative ones or an image will not be formed at the film plane.

It's the ability of a lens to bend light rays and create an image that makes it indispensable for most photography. By converging the rays of light passing

through an opening, a lens makes it possible to use a large aperture (which delivers enough illumination for easy focusing and short exposures) while still providing a sharp image.

FOCAL LENGTH

In chapter 2, the focal length of a lens was defined as the distance from its optical center (roughly, the diaphragm position) to the focal plane when focus is at infinity. For photographers, this is a workable explanation, although lens designers use a definition which is more complicated and exact.

The actual focal length of any particular lens may vary a slight amount from the marking on the lens barrel. But this should be no cause for concern. It's not necessary to know the focal length of a lens beyond rather broad limits in order to take effective pictures.

Image Size

If you select a familiar object of some kind, say a sitting cat, and photograph it, the size of its image on film will depend upon two things: its distance from your camera when the exposure is made and the focal length of the lens.

If, for some reason, you must stay a fixed distance from the cat, then the only way to alter its image size is to use a lens of a different focal length. The longer the focal length of a lens, the larger the image it produces on film. And this relationship is proportional. For example: if camera-to-subject distance remains constant and a 50 mm lens yields a half-inch-high image of the cat, a 100 mm lens will double that, generating a one-inch cat. From the same distance, a 200 mm lens will create a two-inch-high image, or a 400 mm lens will project a cat four inches tall. Of course, increasing the focal length expands both the height *and* the width of an object.

Bear in mind—this focal-length-to-image-size relationship is completely independent of film format. In the above example, whether the 100 mm lens is attached to a 35 mm camera or to a 4 × 5 view camera, the image of the cat is still going to be the same height—one inch. The 35

54

mm negative will be almost filled with it, whereas the 4 × 5 film will include much more of the surrounding scene. However, each object photographed will be the same height and width regardless of film dimensions. When camera-to-subject distance is unchanged, only the focal length of the taking lens dictates image size.

It's a common (and erroneous) assumption that a camera using 120-size film always produces larger images than one using 35 mm film. It seems perfectly logical: larger camera, larger film, larger images. But we've just learned that film size has nothing to do with image size. At any given distance, it is lens focal length that determines the size of any object in the picture.

For example: from the same distance, the "normal" 75-or-80 mm lens on a 120-size camera will indeed create a bigger image than the "normal" 50 mm lens on a 35 mm camera. But if the smaller camera's 50 mm lens is replaced with a 135 mm, for instance, and an object is photographed, its image will now be larger than that furnished by the normal lens on the 120-size camera at the same distance. Of course, because of its smaller format, the 35 mm camera will not be able to include as much of that object's surroundings on film, but whatever can be crammed in *will be larger*.

To sum up: when it's inconvenient or impossible to change the distance between a photographer and his subject in order to render that subject larger or smaller, a change in lens focal length will often serve the purpose just as well, or better. In short, the most fundamental reason for using lenses of differing focal lengths is to control the size of the image.

Angle of View

Angle of view is really an indication of how much "territory" a lens can take in from any given spot. It's based on the diagonal measurement of the film format to be covered and is designed into the lens and its mount by the manufacturer.

As we've seen, from a given distance to subject, lenses of the same focal length will always produce images of the same size, even though different film formats—and, therefore, different angles of view—are in-

*When the same subject is photographed from the same distanc[e]
with a variety of 35 mm SLR lenses, from very wide ("fisheye") t[o]
very long (600 mm mirror), the differences in magnification an[d]
angle of view become strikingly apparen[t]*

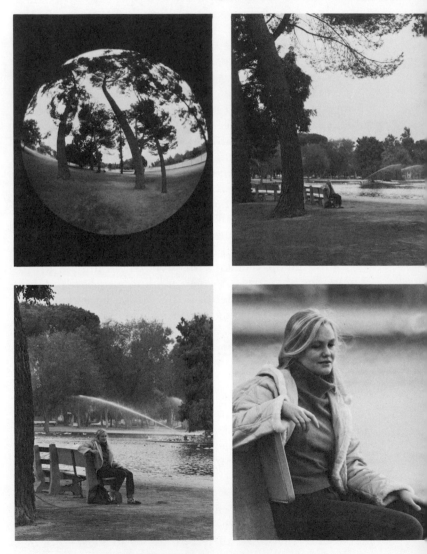

56

volved. Logically, then, there is no direct tie between angle of view and focal length, although it may seem that there is if we confine ourselves solely to a group of lenses designed for just one film size, such as 35 mm. Starting with the longest lens in the series and working toward the shorter end, we see that as focal length decreases, angle of view becomes greater. For example: the 50 mm normal lens has a larger angle of view than a 135 mm telephoto; and a 28 mm wide-angle, in turn, has a wider angle than the 50 mm. But it is only under such special conditions that a close relationship exists between angle of view and focal length.

When more than one film format is involved, the relationship between focal length and angle of view is extremely variable. For example, a 100 mm lens designed for a home movie camera will have a very narrow angle of view, because the size of the film to be covered is small. Another 100 mm lens, this time meant for a 120-film-size still camera, will need a significantly wider angle of view, for it must cover a much larger film area. A third 100 mm lens, designed for the 4 × 5 film format, will need a still wider angle of view in order to cover a negative of such heroic proportions.

In each instance, the lens is the same 100 mm focal length. But since angle of view has changed remarkably with each increase in film size, the movie camera lens is, in effect, a long-focus (narrow-angle) optic, the 120-size camera lens about normal angle for that film format, and the 4 × 5 lens definitely a wide-angle. All three lenses produce exactly the same image size at any given camera-to-subject distance, but the angles of view must be, and are, radically different.

With any focal length, it's desirable to keep the angle of view as narrow as possible—just enough to meet the requirements of the format. Anything more is wasteful and expensive, and may result in lowered image quality. Lens makers keep this principle well in mind when designing today's remarkable optics.

In conclusion, remember that image size is determined only by focal length, and angle of view depends entirely upon lens and mount design. The two lens characteristics, focal length and angle of view, are not necessarily related.

Covering Power

Although focal length and angle of view are not closely linked, *covering power* and angle of view are. A greater angle of view means more covering power, and vice versa. As mentioned in chapter 2, angle of view concerns what's "covered" out front in the scene before the camera, whereas covering power relates to the film size a particular lens can encompass with a good quality image from corner to corner. A lens designed for a 2¼-inch-square negative must have more covering power than one meant for 35 mm, for instance, even though both may be of the same focal length. Covering power, like angle of view, is built into a lens by the manufacturer.

An interesting fact is that covering power is actually increased when a lens is moved away from its infinity position and focused on closer objects. Smaller stops also enhance covering power—one reason why most wide-angle lenses (needing great covering power for their focal lengths) are furnished with only moderate maximum apertures.

Perspective Control

In photography, there are several kinds of perspective. The one that comes to mind first is the common perspective of vanishing point, where railroad tracks or rows of telephone poles seem to meet and disappear at the horizon—or tall buildings seem to lean over backward when photographed from a low angle. However, the photographic perspective we're concerned with in this section has to do with the relative sizes and positions of foreground and background objects within the picture area. There's been much talk and writing about "wide-angle distortion," "telephoto flattening," and the humorous travesty caused by using too short a focal length lens when taking portraits. But one very important principle must always be kept in mind: *perspective* (or "distortion," if you will) *is seldom a function of the lens, but almost always of camera position.*

Some readers will immediately dispute this contention, saying that a shot made with a wide-angle doesn't look at all like one taken with a telephoto—even from the

Various lenses can give various illusions of perspective. For example, the eye can be led to believe that parallel lines will finally meet at the horizon, or that tall buildings are falling over backward, or that objects are much closer together.

same camera position—and certainly gives the illusion of a perspective change. This is true when each exposure is printed full frame to a common size, for the two angles of view are quite different. In the case of extreme focal lengths—a 21 mm wide-angle and a 400 mm telephoto, for instance—the angles covered by each are so unlike the normal angle of the eye that there's a very real illusion of distortion, the telephoto seeming to flatten out front-to-back relationships and the wide-angle to exaggerate them.

However (except with unusual lenses, like fish-eyes), if the wide-angle view is enlarged and cropped to the same size as the full-frame telephoto shot, perspective and spatial relationships will be seen to be exactly the same.

Changing lenses. To illustrate: Suppose a 35 mm camera equipped with a wide-angle lens is put on a tripod and a picture is taken of a scene which includes a distant building, then, without moving the camera, the wide-angle is replaced with the normal 50 mm lens and another shot made. This second exposure will show all objects in the scene enlarged to the same degree while retaining their relative sizes and positions. Just like cropping in the enlarger while printing, there will be no change in perspective, just less of the scene on film because everything has been increased in size due to the longer focal length of the second lens.

Now, with the camera still in the same position, if a telephoto lens is substituted for the normal one and yet another shot made, the cropping effect will be carried even further. All objects in the picture area will be bigger still, but *relative sizes will remain intact.* Using successively longer focal length lenses magnifies every object proportionately but does not change perspective.

To prove this, if 8″ × 10″ prints are made and the first exposure (done with the wide-angle) is enlarged until the distant building is the same size as in the telephoto picture, you'll find that the blown-up wide-angle photo has the same perspective and appearance (discounting grain and decreased sharpness caused by the extra enlarging) as the telephoto shot.

Lenses can also affect image size. In this series of photographs different lenses offer different image sizes. Shot with a 28 mm lens, this photo of California's Griffith Park Observatory takes in a great deal of unnecessary foreground.

The view with a 135 mm lens emphasizes the building itself. All picture elements are further enlarged to the same degree, but there's still no perspective change.

A section of the 28 mm exposure enlarged to match the 135 mm shot proves that as long as camera position does not change, perspective remains the same regardless of focal length.

Changing distance. However, this is not the whole story. Let's do another experiment consisting of three more exposures. Using the normal (50 mm) lens again, let's take a shot of a woman about fifteen feet from the camera, holding a glass of water out in our direction. The subject will obviously be rather small in relation to her surroundings, so let's increase her image size in the next two exposures.

There are two ways of doing this. In the second photo, we'll keep the camera at the same distance but switch to a longer lens to obtain a larger image. And in the last shot we'll put the 50 mm back on and simply move the camera much closer to the woman until the viewfinder is filled and the glass is only a few inches from the lens.

Again, let's make 8" × 10" prints, but this time of all three exposures—and full-frame. It's apparent that perspective in the first picture is normal and entirely satisfactory, even though the subject is too far away and appears too small in relation to her surroundings. In the second shot (taken with the longer lens), perspective is identical to the first, but image size is now agreeably bigger and better.

Interestingly, the third exposure (made with the same lens as the first) shows a dramatic change. Although the woman's size is about the same as in picture number two, perspective has been drastically altered. Because, when the picture was taken, the position of the glass was so close to the lens in relation to the subject's head, the glass appears grotesquely large and out of proportion. Reality has been strained by a camera-to-glass distance much shorter than the eye would normally encounter in real life. And it was camera position, not the lens used, which altered the perspective.

Now you can understand something of what is meant by so-called "wide-angle distortion." For example, if a wide-angle lens is used to make a head-and-shoulders portrait of a person, the result is likely to be a bulging nose jutting out of a moon-shaped face that's flanked by tiny ears. The fault is not really with the wide-angle lens; it's with the compressed camera-to-subject distance—caused by choosing an inappropriate lens for the purpose

From 15 feet away, perspective appears normal with a 50 mm lens on a 35 mm SLR (above left). At the same distance a 135 mm lens enlarges the main subject without affecting perspective (above right). At left, the 50 mm lens is used again; and the camera is moved closer to the subject so that the image will be as large as the one produced with the 135 mm lens. See how the perspective has been radically changed—proving that it's camera position rather than focal length that affects perspective.

A wide-angle lens must be used very close to a subject to get a large image of the face. This short camera-to-subject distance can produce a disturbing or unflattering perspective.

If the image is enlarged to a similar size, it's apparent that the same wide angle lens used from a greater distance provides a more normal and pleasing perspective. Again, it's camera position, not the lens, which controls perspective.

in the first place. With a short focal length lens, the camera must be brought so close to the face in order to obtain a large-enough image that perspective is distorted. (Actually, the perspective is valid and accurate *from that position*, but our eyes and brains are not used to viewing the world at such close range, so distance relationships are seen as being very strange indeed.)

If that same wide-angle lens were used at a distance of six or eight feet and the resulting image enlarged until the subject filled the picture area, perspective would be normal and pleasing. That's why lenses of from 1½ to 2 times normal focal length (75 mm to 105 mm on 35 mm cameras) are generally used to make portraits. Their longer focal lengths allow a suitably large image size from a distance which gives a pleasing perspective.

Changing both lens and distance. Another important experiment (one that demonstrates a powerful photographic tool you can use to control composition) involves changing both lens *and* camera position simultaneously. First, beg, borrow, or buy as many lenses of different focal length as you can for your camera. Next get a willing friend to help by posing. Place your friend in an open space with a recognizable tree or building some distance in the background. Then, starting with the shortest lens you have, take a series of shots in which your friend appears the same size in each frame. With the shortest (widest angle) lens, you'll have to place the camera quite close to your subject in order to get a sufficiently large image. As longer and longer lenses are used, you'll have to move back farther each time to keep your friend's image size the same.

After prints are made, notice what happens to the tree or building behind your subject. With each longer lens, background objects have grown proportionately larger than the foreground subject. Your friend has, of course, been enlarged along with the background, but your moving away each time has kept him or her the same relative size. However, the distance between you and the tree or building was so much greater in each shot than between you and the foreground subject that your moving back has had little effect here. The background has gained in magnitude relative to your friend with each increase in focal length.

65

A series of pictures
taken with lenses
whose focal lengths
cover a range from full
fisheye to 600 mm tele-
photo, shows that if
camera position is
altered to keep the
main subject about the
same size as each lens is
changed, the back-
ground looms larger
and larger with each
successive shot.

Use this effective control technique in your photographs. Select a lens focal length not only for the image size it produces but also for the flexibility it gives you in choosing the distance between you and a subject's various elements—and therefore the perspective. Minimize or increase the importance of backgrounds at will.

As you can see from the above experiment, wide-angle lenses (largely because of the close range at which they're typically used) tend to expand distances and make rooms and scenes look larger and more spacious than they really are. Long-focus and telephoto lenses have the opposite effect. Their characteristic long-range use seems to compress distances and flatten perspective, sometimes making both near and far objects appear to be about the same size.

The role of the print. It should be clear now that camera position is the prime factor controlling perspective. And we've seen that choice of lens also plays a part, tending to dictate camera position as far as lens-to-subject distance is concerned and determining whether the angle of view is normal or strange to the eye. But there's one ingredient we haven't yet added to the recipe for perspective control—print viewing distance. The separation between print and observer has an important effect on the image received by the brain.

One way to achieve realistic viewing perspective and to eliminate most "distortion" is to make all prints by contact (the same size as the negatives) and then to look at them from a distance equal to the focal length of the taking lens. For example, if negatives from a 35 mm camera are taken with the normal two-inch (50 mm) lens, the tiny contact prints have to be viewed from a two-inch distance to maintain correct perspective. Even with a magnifier, this procedure is clumsy; with the naked eye it's quite impractical. Fortunately, it's also unnecessary.

All we have to do is enlarge any print to a size that can be viewed from the comfortable distance of about fourteen inches—as though the picture were originally shot with a fourteen-inch lens. In the case of a two-inch focal length taking lens, two goes into the 14 inch viewing distance seven times, so we need a 7 × blowup to

67

obtain the correct print size (about $7 \times 10\frac{1}{2}$ inches from a full-frame 35 mm negative). That's one of the reasons why $8'' \times 10''$ enlargements from smaller negatives look so much better than contact prints.

However, you need not be dogmatic about correct viewing distance. When photos are shot with lenses of varying focal lengths, and prints range from contacts to giant blowups, determining ideal viewing distances can become a needless mathematical nightmare. Besides, the sometimes strange and jarring perspectives which result from "incorrect" viewing distances are often appealing in themselves. Remember—as a composition tool, perspective can be used in any way you choose to create memorable photographs.

APERTURE

Although focal length is the prime characteristic of a lens (since so many other properties depend on it), *aperture* and its related optical functions are a close second.

To many photographers, aperture has only one meaning—the "speed" or top light-gathering ability of a lens. While this is certainly an important quality, it's not the whole story. Aperture is also involved with the function of f stops, depth of field, circle of confusion, hyperfocal distance, covering power, definition, and the minimizing of lens aberrations. We'll cover some of these important areas in the remaining pages of this chapter.

Lens Speed

The maximum light-grabbing power of a lens is, admittedly, one of its more glamorous features. "Fast" lenses usually generate an undeserved share of attention from novice photographers—perhaps because lens speed is closely related to lens cost, and both bring a large measure of ego satisfaction. Also, there's the persistent myth that "fast" means "better."

It's true, however, that a fast lens does have certain advantages over one of medium or slow speed (although the benefits are often overrated). One important

plus resulting from a large aperture is the projection of a brighter finder image, which allows simpler focusing with reflex or view cameras. Not only is the image easier to see, but it snaps in and out of focus with increased facility because of greater limits on depth of field. (More about this later.)

In addition, a lens of superior speed will allow available-light photography under conditions which might otherwise be impossible, or at least extremely difficult, such as a situation in which a tripod and a slower shutter aren't practical and the fastest film available still isn't sensitive enough for hand-held shots. Of course, flash can always raise the illumination level and allow a much slower lens to be used. But then (unless you have an auto-focus camera), there's still the problem of trying to focus accurately with a slow lens in the murk that exists before the flash goes off.

Yes, fast lenses do have advantages, but their larger apertures also entail higher cost, and not just in money. In order to build speed into a lens, a designer must usually sacrifice some other desirable qualities as a necessary trade-off. For example, the maximum correction of aberrations may get a lower priority, or standards

Besides providing greater ease in viewing and focusing, a "fast" lens makes it possible to take pictures in dim light without a tripod.

of definition may be reduced. And even if an attempt is made to keep image quality as high as in a slower design, more elements will be needed—adding to weight as well as to price.

There is evidence that an $f/1.4$ lens stopped down to $f/2$, for example, will often produce a better quality image than an $f/2$ lens at maximum aperture, even though the difference may be discernible only to a technician using an optical bench. However, when *all* lenses are used wide open, those with medium ($f/2$ to $f/4$) or small ($f/4$ to $f/8$) maximum apertures are almost always sharper, better corrected, lighter in weight, and lower in cost than similar optics of higher speed. To give up these desirable characteristics for the slight advantage of a brighter viewfinder and the ability to capture an occasional image under adverse lighting (especially when flash is a practical option) is questionable.

A "speed" lens ($f/1.4$ or faster) is certainly nice to have if you can afford it. The 50 mm $f/1.4$'s available as standard equipment on current top-notch 35 mm cameras are excellent lenses, suitable for use under a variety of photographic conditions. But unless you intend to do a great deal of low-light shooting without flash, the extra speed is largely wasted—along with some of your money.

For most picture-taking, when illumination levels are comfortable, a medium-speed lens will do the job just as easily and may provide a superior image. Besides, I'm a great believer in the use of tripods or other camera supports. Except in a tiny minority of situations, some such device combined with slower shutter speeds will let a lens of moderate aperture excel even in dim light. Try it. You may change your whole approach to "available darkness" shooting.

F Stops

Although photography's first lens "stop" was a device to improve optical performance, today's adjustable iris diaphragm is used to control the amount of light reaching the film plane during any given exposure period. Aberrations are now corrected largely by optical means.

In the past, purely arbitrary numbers were assigned to various lens openings, but we now use a mathe-

matically derived series—the f stops—to establish a common standard of light transmission, regardless of lens size or type. For example, if a lens of any length is adjusted so that the diameter of its diaphragm is just ⅛ of its focal length, you have $f/8$ (the ratio of focal length to diaphragm opening). If the stop is readjusted to ¼ the focal length, you have $f/4$, etc. It's for this reason that any f stop on even the shortest lens will admit about the same amount of light as the identical stop on even the longest one. The longer the focal length, the larger the aperture must be to arrive at the same f stop and let in the same amount of light. The greater quantity of light transmitted by the bigger opening is offset by the longer distance it has to travel.

Although other progressions have been used in the past and sometimes still are, most manufacturers now engrave lens barrels with the following stop designations (going from the widest to the smallest openings): $f/1$, $f/1.4$, $f/2$, $f/2.8$, $f/4$, $f/5.6$, $f/8$, $f/11$, $f/16$, $f/22$, $f/32$, $f/45$, and $f/64$. No one lens ever uses this full spectrum. Shorter ones tend toward the smaller numbers ($f/1.4$ to $f/16$), while longer lenses stay in the upper (slower) range ($f/5.6$ to $f/64$). These limits are only approximations, since individual optics vary considerably.

F stops are arranged so that each larger number delivers only half the light of its smaller neighbor; that is, the bigger the f number, the smaller the opening and the less light admitted. Or, going in the other direction, each smaller number doubles light transmission. (Since each f number is really the denominator of a fraction, bigger denominators mean smaller values, and vice versa.)

You may wonder how such an odd progression of numerals was arrived at. Each one does not appear to be half or double the stop adjacent to it. That's true, but the *square* of each one (with some minor rounding off) is half or double, and it's the square which indicates relative light intensity.

F number:	1	1.4	2	2.8	4	5.6	8	11	16	22	etc.
Square:	1	2	4	8	16	32	64	128	256	512	etc.

The big advantage in having each stop transmit half or double the light intensity of its neighbor is that it

matches the arrangement of the shutter, which also halves or doubles the light with each change in speed setting. Thus the two controls can be easily manipulated relative to each other. Some cameras even link them mechanically so that the selection of a faster shutter speed, for instance, will automatically open the diaphragm a sufficient amount to keep the exposure level identical.

Close-up photography requires exposure compensation. This poses no problems for today's automatic 35 mm SLR cameras.

Although shutters almost always limit their speeds to the half-or-double arrangement (one exception being the stepless shutter found in some automatic cameras), the diaphragm can be positioned over a continuous range —on exact *f* numbers or anywhere in between. In fact, half-stop detents between the marked openings are commonplace conveniences on modern lenses. Such flexibility in setting the aperture allows more precision in exposure control.

The *f* stop numbers apply at all times when a lens is attached directly to a camera in the normal manner. But when extension tubes or bellows are used in order to take pictures at less than about eight times the focal length of the lens, the light reaching the film is reduced. The greater the distance between lens and film plane, the more the incoming light is spread out and the dimmer it becomes. It's as though the lens, in its normal position, were being stopped down.

However, since most cameras today have built-in meters to measure light intensity at the film plane, any necessary adjustment in exposure is taken care of automatically. With cameras not having built-in meters, a photographer can consult a handy chart or calculating dial to see just how much to increase exposure for extreme close-ups.

To conclude: Under normal conditions of use, any lens at any given *f* stop will pass about the same quantity of light as any other lens at the same stop, regardless of focal length. There'll be some slight differences due to lens design and the absorption characteristics of the glass, but don't let that bother you. An *f*/8 is an *f*/8 is an *f*/8.... So switch those lenses and have fun.

Depth of Field

When a lens is focused, it produces an image of maximum sharpness at only one specific distance from the camera. Imagine this distance as being represented by a thin invisible "wall" which is positioned exactly parallel to the film plane. Everything within the field of view which falls along this wall is in perfect focus. At all other distances, objects are more or less "unsharp".

With a 50 mm lens at f/2, there is little depth of field (top left). With the same lens, camera position, and point of focus, but with the lens closed to f/16, depth of field increases (top right). Positioning the camera as before, but using f/8, results are adequate.

However, images in front of or behind this wall don't jump out of focus suddenly. They fall off in sharpness gradually (in both directions), as distance from the plane of exact focus increases, until limits are reached where image clarity is no longer acceptable.

Depth of field, therefore, is the zone ranging from the nearest point of acceptable sharpness, through the plane of exact focus, to the acceptable point on the far side. This zone varies in depth with: 1) the focal length of a lens, 2) the distance at which a lens is focused, and 3) the size of the aperture being used.

All this brings up an interesting question—just what *is* acceptable sharpness, anyway? Acceptable by what standard, by whose "yardstick"? Even though technical criteria for determining sharpness with extreme accuracy do exist, it really boils down to what the human eye will accept as satisfactory. Naturally, individuals vary in their perception of sharpness, but averages can be arrived at, and it's these averages that form the basis for depth-of-field charts and tables. Simply put, the limit

of *acceptable sharpness* is the distance from the plane of exact focus at which the eye begins to see fuzziness instead of a clear-cut image.

It would be helpful if the matter ended there, but it doesn't. There's also the film format to consider. Small negatives (such as 35 mm) are often enlarged several times when prints are made; and the more an image is enlarged, the more any lack of definition is revealed. Therefore, lenses designed for small cameras usually have an extra measure of sharpness built into them; and depth-of-field scales, charts, and tables relating to these lenses are computed to more stringent standards of definition than those prepared for larger formats. As a consequence, when images produced by small cameras are enlarged, carefully made prints often display a sharpness and depth of field comparable to photos obtained from much bigger negatives.

Depth of field, then, is influenced by the amount of enlargement in the print. Other factors involved in "acceptable" sharpness and depth are the distance from which the print is viewed and the personal taste of the viewer. As a result, because there are so many variables to consider, depth-of-field scales, tables, and charts are compromises at best. However, they do serve as valuable references for average shooting and printing conditions.

As previously mentioned, three factors control the front-to-back zone of acceptable sharpness when a scene is photographed: lens focal length, aperture, and distance setting. Depth of field can be increased: 1) by using a shorter focal length lens, 2) by stopping down to a smaller diaphragm opening, 3) by focusing at a greater distance, or by any combination of the three. Conversely, a longer lens, a larger opening, or a shorter lens-to-subject distance will decrease the range of sharpness. An examination of some depth-of-field tables (usually found in your camera's instruction booklet) will quickly give you an insight into these relationships.

Depth-of-field example. Suppose you are photographing a person in a setting which contains important subject matter from near the camera to the far distance, and you want all of it to appear sharp. You find (from a

chart, from the depth-of-field scale on your lens, or from simply looking through your camera's viewfinder after closing down to a preselected f stop) that you can't bring everything into satisfactory focus with the lens/aperture/distance combination you're using.

Your first thought may be to stop down the lens a bit more. Good. This is usually the easiest and best approach. But let's assume the light level is low and you're without a tripod. You know the slower shutter speed you'll have to use will not prevent hand-held-camera movement, so stopping down is out. You next try backing up so that everything is farther from the lens. This may help some, or even solve your depth problem completely, but you find you don't like the altered perspective, so that option is scrapped, too. The only remaining remedy is to use a shorter focal length lens—which means a wider angle of view and a smaller image.

This lens change will probably give you the depth you need, *but only if you don't move closer to the person in order to retain the same image size you had with the original lens!* The truth is that no matter what focal length lenses are used, if the camera is moved so that image sizes are identical, depth of field will also be identical (assuming the same f stop, of course).

Zone focusing. Let's take a more common situation. You have only one lens to work with, and you've picked out a great spot from which to shoot (so you don't wish to change the camera position). You'd like everything from about 7 to 12 feet from the lens to be in good focus. Your problem is simply to find the f stop and the point of focus that will give you the desired results. There's plenty of light, so there are many stops from which to choose. How do you do it?

You do it with the depth-of-field scale on your lens barrel. As you turn the focusing ring, you'll notice that the distance numbers move past an index mark which shows the point of exact focus. Spread out equally on both sides of this mark are other numbers corresponding to the f stops available on your lens. Try setting the nearer distance you want (seven feet) opposite the f/11 indicator at the low end of the scale (representing the shortest distances). Then look for the f/11 on the other

Zone focusing (with the help of your depth of field scale) allows you much more freedom in shooting action.

side of the index mark and see what distance is displayed there. On a normal 50 mm lens, it'll be about 20 feet. Your depth-of-field scale has now revealed that at f/11, with the focusing ring properly adjusted, you can obtain sharp images within a range of about 7 to 20 feet from your camera.

That's fine. It gives you all the depth you need, and more. If there's enough light to use f/11 with a suitable shutter speed, you're in business. But if you'd like a bigger opening in order to use a higher shutter speed, try f/8 on the depth-of-field scale. Set your nearer limit (the same seven feet) opposite the lower f/8 mark and check the other end of the scale again. This time the far distance is 12 or 13 feet. Great! Just what you wanted—a depth of 7 to 12 feet. *And now there's no need to focus through the viewfinder.* Leave the focusing ring just where it is. You've found both the correct f stop for the depth of field desired and the exact position of the focusing ring. Your setting of the distance markings against an appropriate f stop on the depth-of-field scale has done the whole job automatically, *provided, of course, you use the same f stop when making the exposure.*

If the near distance is the critical point, set this against the depth scale and see what far distances are

With 7 feet set opposite the f/8 mark on the lower end of a 50 mm lens depth-of-field scale, the upper f/8 index corresponds to about 13 feet. Thus the depth-of-field in this case extends from 7 to 13 feet.

available. But if the far distance is more important, start with that end. By setting one distance or the other against various *f* stops, you can easily determine just how much depth you'll have and exactly where it will fall.

If a situation calls for a zone of sharpness extending from infinity (as far as you can see) down to a definite near distance, just set the infinity symbol (∞) against each of the stop indicators in turn until the same *f* number at the other end of the scale closely matches the near distance wanted. This procedure is known as focusing at the *hyperfocal distance* and is a time-honored technique for obtaining maximum depth at any particular *f* stop. It's especially handy when there's a need to make fast-action "grab shots" over a wide range of distances and you don't have time to refocus for each exposure. If the near distance on the scale isn't close enough at even the smallest stop available, move back from your subject until the nearest important detail falls within the depth limits.

Because built-in depth-of-field scales are computed for a single focal length at a time, zoom lenses (with their multiple focal lengths) don't have them. However, there are separate charts and tables available which will provide the information you need for any of the focal lengths you might be using on your favorite zoom.

Try zone focusing. Use the above techniques. You'll increase the fun and flexibility of your photography and

Placing the infinity mark opposite an f stop number on the upper end of a depth-of-field scale puts the camera in focus (at that stop) from infinity down to the number of feet indicated next to the same f stop on the scale's lower end. In this case (at f/11) from infinity to about 11 feet.

bring in some great shots you've overlooked in the past. At your next indoor party, where room lights are apt to be low, take advantage of flash. It will allow the use of small stops and result in a generous depth of field. With your present knowledge of zone focusing, you can make your exposures with ease and simplicity while others continue to squint through their viewfinders, trying to focus each image individually in the gloom between flashes.

Advantages of limited depth. Often, a photographer wants less, rather than more, depth of field in a picture. A typical need for limited sharpness occurs when a portrait is taken against a cluttered background. A shallow depth allows a well-focused subject to stand out from an unobtrusive softness. An easy way to obtain this effect is to open up to a large f stop, or use a longer lens, or both. It helps to move in closer to the subject, too. This technique is known as *selective focus.* It's more appropriately described as *selective depth* and is also called *differential focusing.*

Of course, the most obvious situation in which the zone of sharpness needs to be restricted as much as possible is the simple act of focusing. When the depth is very shallow, objects snap in and out of focus with great clarity. That's why modern lenses for most 35 mm and 120-size cameras are designed to be wide open for focusing. They stop down automatically, before exposure, when the shutter release is pressed. Besides curtailing

79

Selective focus and limited depth of field both help to minimize unwanted background in this outdoor portrait. A medium telephoto is especially helpful in this situation.

depth, a wide-open lens also provides a much brighter viewfinder image. Both factors contribute to ease of focusing.

Incidentally, a good principle to remember regarding depth of field is that at normal shooting distances the zone of acceptable sharpness extends about twice as far behind the spot you've focused on as it does toward the camera. In other words, the point of greatest sharpness is about one third of the way into the acceptable area. At very close distances, the depth zone is split about 50-50.

Depth of focus. Before leaving the subject of depth of field, we should talk about its little brother, *depth of focus.* The two terms are often confused. Unlike depth of field (which is calculated at the subject location out in front of the lens), depth of focus is measured inside the camera and has to do with the very limited zone of sharpness at the film plane. You should know enough about the two terms to avoid using one in place of the other, since depth of field is the important concept for a photographer. Depth of focus is really of concern only to a lens or camera manufacturer.

Definition

A desirable characteristic of any camera lens is good definition—the ability to deliver crisp, clear, finely detailed images. Normal focal length lenses of moderate speed can be made razor sharp with a minimum number of elements. However, when a lens is designed for more scope than found in a standard optic, such as larger aperture, wider angle, or the ability to zoom, extra elements must be added in order to maintain the same good definition. Understandably, these extra-element lenses with their highly complex mounts are more expensive.

Often, within its special close-up range, a macro lens is even sharper than a standard optic. Or a long-focus lens with an unusual component (such as fluorite crystal) may have a slight edge under some circumstances. Extra quality in construction has an effect on definition, too. But all these exceptional features increase the cost of a lens. The fact is that as a result of modern technology and materials, even relatively inexpensive optics compete favorably with the super-stars. Any discrepancies in definition can usually be detected only through careful analysis on an optical bench. In practical picture-taking terms, there's no difference.

Extra elements, special glass, a complex mount, and quality construction—these are all ingredients which may be found in the lens itself. They can't be improved upon by the photographer. But he or she can certainly undermine what's already there by the way a lens is used.

For example, choice of subject matter has a strong influence on the appearance of a photographic image. An object with soft outlines and few features will not seem to be as sharp as one rich in detail, no matter how carefully focused each has been. And lighting plays an equally important role. Flat, frontal illumination tends to wash out detail and reduce contrast, whereas cross lighting (from the side) sets up countless little shadows wherever a surface is not perfectly smooth. The blackness of the shadows contrasts with the normal tones of a subject, producing a richly detailed pattern which can show off the resolving power of a good lens in fine style.

A subject with soft outlines and few details, will often not appear to be critically sharp, especially when the subject is also lit from the front.

Moral: to increase the apparent sharpness of an image, pick a subject with lots of detail and enhance it with appropriate lighting.

Then there's the choice of film. Fast films usually resolve less detail than slower ones. But even within this broad generalization, there are factors which can alter the results. Overexposure of the film can scatter light within the emulsion grains and detract from sharpness.

Overdevelopment can do the same damage by causing grains of silver to clump together too much. Don't ever blame a lens for unsharp pictures before you examine your own exposure and development techniques.

As we've already discovered, choice of aperture can affect resolution, also. A lens wide open is never quite at its best. Nor is it the most effective when stopped down too far, for diffraction (the scattering of light when

This wooden gate, rich in detail and photographed with cross lighting, emphasizes the sharp results possible with today's excellent lenses.

it passes through a small opening) then takes the fine edge off definition. Most lenses provide their best resolution when they're closed down about two or three stops from their maximum openings.

However, the most common contributors to unsharp images are camera movement during exposure and faulty focusing. Subject movement can cause poor results, too, but not nearly so often as a jiggling camera or an inaccurate distance setting. Faster shutter speeds and a steadier stance can help overcome unwanted motion. A tripod can help even more. Better focusing simply requires more care and precision when using whatever focusing device the camera provides.

It's unfortunate that many picture-takers never realize just how crisp and sharp their lenses really are. Poor camera handling and film processing rob their expensive optics of the chance to deliver all the quality built into them. Photographers themselves create most of the gremlins which destroy good definition.

Despite all the above, don't be discouraged if your photos aren't as finely detailed as aerial survey maps. It's not as important that they be. Evaluate sharpness in your own prints according to personal standards. If you are satisfied with the image quality and performance of a lens, and you understand how its optical characteristics help make or break the photographs you take, then the lens is obviously suitable. Don't look for exaggerated results like super sharpness in 16" × 20" blowups from 35 mm negatives. The fun and adventure of photography is what really matters. Go out and shoot, always trying to do the best you know how. I believe that even a less-than-perfect picture is a great deal better than no picture at all.

4

The 'Normal' Lens

Of all the lenses which may be attached to your inter-
changeable-lens camera, the one that came with it—the
so-called "normal" lens—is often the most useful. A great
many photographers find it's the only one they ever need.
Even when several interchangeable optics are available,
the standard (normal) lens is often used more frequently
than all the others combined.

What is a normal lens, and why is it so often the
best one for a particular photographic situation? A nor-
mal lens is one having a focal length roughly equal to the
diagonal measurement of the film format being used. For
example, the 24 × 36 mm negative produced by a 35 mm
camera has a diagonal of slightly over 43 mm. However,
lenses from about 40 mm to 58 mm in focal length are
considered in the "normal" range for this size negative,
with 50 mm being the most common. Other film formats
have their own normal focal lengths which match their
diagonals.

What's so special about the diagonal of a film
format that its length should be used as a standard for
lens size? It probably has to do with the fact that when
lens focal length approximates a format's diagonal mea-
surement, the appearance and perspective of the result-
ing image closely matches that seen by the human eye at
the same distance. In other words, such a lens provides
the most *natural-looking* photos.

Then, too, the normal focal length is usually the
best compromise between telephoto and wide-angle
needs, satisfying the requirements of most photogra-

phers at least 90 percent of the time. This observation is borne out by the fact that many popular cameras do not offer lens interchangeability at all. The lens furnished is fixed in place at the factory and is not meant to be removable. Therefore, with the exception of accessories like filters and close-up attachments, such cameras are limited to just the one lens. And yet, most photographers using this type of equipment find it highly satisfactory and have countless successful pictures to prove it. It's no surprise, then, that even with interchangeable-lens cameras, the standard lens is the one chosen so often.

ADVANTAGES

Besides the obvious advantage of a focal length which suits the requirements of most photographic situations, the normal lens incorporates other benefits as well. When

The "normal" lens is compact and portable, and its focal length is ideal for most photographic situations when a photographer is out looking for fresh subjects.

The greater light-gathering power of a "normal" lens makes nighttime picture-taking much easier.

compared with the whole range of focal lengths available for an interchangeable-lens camera, the normal lens is certain to be lighter and smaller than any telephoto, long-focus, or zoom, and generally more compact than any of the wide-angles (due to their complex retrofocus designs). Because of this compactness and portability, the normal lens is the one most likely to be on the camera when a photographer is out scouting for picture opportunities—especially since carrying cases are usually designed expressly for the normal-lens-and-camera combination.

Then there's the matter of lens speed. For many technical reasons, the normal lens—despite its lighter weight and smaller size—can be given a larger maximum stop than one of either longer or shorter focal length. This extra speed further increases its versatility, allowing easier framing and focusing through the camera's viewfinder, higher shutter speeds to stop more action, and

well-exposed pictures under a greater variety of lighting conditions.

And, not insignificantly, all these benefits are usually delivered at a price as low as—if not lower than—any other optic of appreciably different focal length but equal quality available for a particular camera. The greater mass production of the normal lens contributes most to this saving. The design economies inherent in the normal focal length account for the rest.

DISADVANTAGES

The chief disadvantage of the normal lens is that while its focal length is usually the best possible compromise, it can't be the ideal optic for every occasion. When attempting to reach out and bring a distant subject in closer, a photographer will find the normal lens is too "short"—has too wide an angle—and therefore doesn't provide enough magnification. On the other hand, a group of people in an average-size room probably can't all be included in the same shot, because in this situation the normal lens is too "long" and doesn't cover a wide enough field of view.

Another drawback is that the normal lens, being of fixed focal length, is unable to perform all the varied functions of a zoom. Also, it can't focus as close as a macro or selectively shift the image like a perspective-control lens.

Plainly, there are shortcomings—which is why so many other kinds of optics are manufactured—but, for most of us, the normal lens is a handy and reliable friend that will see us through most of our photographic efforts.

TYPICAL USES

As noted above, the normal lens is a convenient one to have on the camera when you're wandering around looking for pictures. Its "in-between" focal length gives you the best chance to capture unexpected subjects at the distances you're most likely to encounter them, and its relatively small size and light weight makes it less bur-

The covering power of the average flash gun closely matches that of a "normal" lens.

densome on long walks. It's also the most logical lens to use for flash pictures, since the coverage of most flash guns just about matches its field of view. And even if you elect not to use flash in dim light, the normal lens is still the best choice because its large aperture makes available-light shooting easier.

The "normal" lens can cover a wide range of subjects with ease and efficiency. In the above photograph, the great depth of field offered by a "normal" lens and small aperture enables the photographer to keep both background and foreground in focus.

It's a great lens for photographing kids, pets, friends, neighbors, family outings, vacations, and a host of other important and frequently encountered subjects. The normal lens is the all-around utility member of any optical team.

However, before leaving this chapter, it must be emphasized that the term *normal lens* can be applied to other focal lengths besides the one which arbitrarily matches the film format's diagonal measurement. It's already been mentioned that the 43 mm diagonal of a 35 mm-camera negative has spawned "normal" lenses from about 40 mm to 58 mm in focal length, all perfectly acceptable for the purpose.

The normal lenses for cameras producing 2¼-inch-square (6 × 6 cm) images are usually 75 mm or 80 mm, somewhat shorter than the 85 mm film diagonal. On the other hand, for various technical and traditional reasons, the normal lenses (other than zooms) for movie cameras are almost always 1½ to 2 times longer than the diagonal of the film format.

The "normal" lens is well suited to travel photography because of its light weight and versatility.

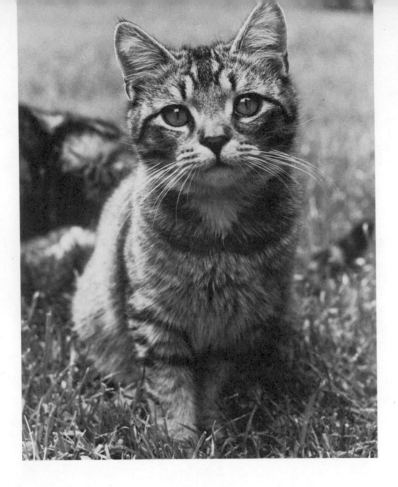

Sometimes photographers make their own rules, using focal lengths even further removed from the diagonal measurement. One may use a lens as short as 28 mm most of the time. Another may favor a 105 mm. These unlikely focal lengths then become normal for the types of pictures taken by these particular photographers. Therefore, these optics serve as "normal" lenses in the truest sense, and there's no reason why they shouldn't be considered as such. If you happen to shoot most of your own photos with an 80–240 mm zoom, who can really argue that it's not your normal lens?

5

The Telephoto Lens

What do you do when you want to photograph a colorful bird, a pretty girl, a professional golfer, but your subject is so far away that you can't get a decent-size image with your normal lens? In many instances, you can just move a lot closer. But then you risk the bird flying away, or the girl becoming hostile, or the golfer becoming distracted. It's often better to simply stay where you are and bring the subject closer to you by replacing your normal lens with one of longer focal length.

How much longer? That depends upon the distance between you and your subject as well as on the size image you want. Realistically, it also depends upon what lenses are immediately available in your gadget bag. If you have with you only one lens that's longer than your normal optic, the choice is clear. Put it on your camera with the knowledge that if it's not exactly what you need, it will at least be an improvement. But if you have more than one longer lens at hand, you may find that you can obtain an image of just the right size.

If the bird, the girl, or the golfer is really a long way off, use the longest lens you can support without camera shake. (A tripod can be a great help, for it allows you to use longer lenses than can be managed hand-held.) But if the distance between you and your subject isn't overly large, an optic of moderate focal length (135 mm, for instance) may be ideal.

To determine what size lens will do the best job for you, proceed in this fashion: Look at your subject through

93

Telephoto lenses are good for isolating dramatic action in sporting events

the camera's viewfinder with the normal lens in place. (Let's assume you're using a 35 mm camera and that the normal optic is 50 mm.) Observe the height of the subject within the frame. If doubling the height would fill the viewfinder nicely, then all you need do is double the focal length of the taking lens (100 mm instead of the normal 50 mm) to obtain the required magnification. Or if a four-times height increase would do the job better, put on a lens that's four times the focal length (200 mm instead of 50 mm). The technique should be easy to understand and to apply.

50 mm

100 mm

Doubling the focal length will double the height of the image size.

94

However, if you're not comfortable with this procedure (and you have ample time), just put on any lens you think will do the job and look through the viewfinder at your subject. You'll quickly be able to tell whether or not your choice was correct. If not, switch to another lens and try again.

TELEPHOTO OR LONG-FOCUS?

There are two types of optical design used to produce lenses of longer-than-normal focal length—the conventional (or long-focus) and the telephoto. With the long-focus design, the focal length of a lens matches its actual physical length very closely. But with the telephoto, a different arrangement of lens components allows its physical length to be pared down to as little as 50-60% of its focal length. This saving in size reduces weight and bulk, making a telephoto easier to carry and to use.

In lenses of moderate power (up to 2 or 3 times the normal focal length), a telephoto design offers little size advantage over a true long-focus lens while imposing some optical limitations of its own. Aberrations in a telephoto cannot be corrected as well as in a conventional lens of the same focal length, and for this reason maximum apertures must also be kept smaller. However, when focal lengths are sizable and compactness is important, savings in weight and bulk make the telephoto practical.

But no matter which of the above two designs apply, lenses with focal lengths longer than the normal lens for a particular format are customarily referred to as telephotos, or just "teles." Although it's not accurate to call every such lens a telephoto, it's a convenient verbal shorthand.

MEDIUM-LONG LENSES

The shorter "teles," those with only a moderate amount of magnification over the normal optic, are the most useful of the long lenses. For the 35 mm camera, these

medium lenses range from about 80 mm to 150 mm, with 135 mm being a very popular size. Lenses of this modest focal length are lighter, smaller, faster, and easier to carry than their bigger brothers. They're also less expensive to buy. But their chief advantage is that they're the ideal length for most of the subjects for which a telephoto is needed at all.

A 135 mm lens on a 35 mm camera is just right for a trip to the zoo, or to catch kids and pets at play from an unobtrusive distance, or even to take tight head-and-shoulder portraits having a pleasing perspective. With a set of extension tubes to permit closer focusing, a moderate tele will allow you to take close-ups of insects and other small creatures from a comfortable distance while still retaining a sufficient balance between aperture and depth of field to make the effort worthwhile. On the other hand, mountains and distant scenery can be brought up closer behind a foreground subject through the use of a short tele, thus adding impact and interest to what might otherwise be an ordinary shot.

A 135 mm, or a zoom covering the medium-tele range, is usually the first additional lens a 35 mm-camera owner will acquire. It, along with the normal optic (and perhaps a moderate wide-angle), will handle all but very specialized photographic situations.

A medium-long lens will serve you well in many situations where, for one reason or another, it's important to keep a reasonable distance between you and your subject.

When animals cannot be approached close enough to make a
large image with a "normal" lens, longer or telephoto lenses
can solve the problem (see Chapter 5).

(Opposite page) Although a lens of normal focal length can be used for portraits, a longer one (or a zoom in the short tele range) produces a more natural appearance of the subject (review Chapter 3).

(Below) A longer lens used from farther away could have changed the perspective in this photo by keeping the girl the same size while magnifying the rocky spires in the valley below (Chapter 3).

(Opposite page) The "normal" lens on a 35 mm SLR camera—50 mm—will easily handle a wide variety of subjects, including vacations (Chapter 4).

(This page, below) Beetles and other small creatures can be recorded at or near life size by means of close-up lens attachments, extension tubes, lens-plus-bellows, or a macro lens (Chapters 8 and 9). (This page, bottom) Any camera that will accept different lenses will also accept inexpensive extension tubes, making possible colorful flower close-ups like this one of a golden prickly pear (Chapter 9).

(Left) A polarizing filter, used under the proper conditions, renders the sky as a rich blue background, dramatizing the foreground subject (see Chapter 9).

(Below) A telephoto lens is ideal for reaching out across impassable terrain, but it usually needs extra support. A tripod makes handling easier and insures maximum image quality. (Review Chapter 5.)

Because a "normal" lens is almost always "faster" (that is, has a larger maximum aperture) than a telephoto, a wide-angle, or a zoom, it is usually the best choice for after-dark shots (review Chapter 4).

Subjects that are relatively close and also fast-moving can be captured by one of the modern "one-touch" zoom lenses (see Chapter 7).

LONGER FOCAL LENGTHS

Lenses whose focal lengths run from about three to ten times that of the normal optic for a given format (for example, 150 mm to 500 mm for the 35 mm camera) are less useful for general picture taking than the shorter teles. There are few subjects which require as much magnification as they provide; therefore, lenses in this range are usually considered to be special-purpose optics. Many advanced hobbyists acquire lenses of this length only after they begin specializing in a field (such as wildlife photography) where getting close to a subject is almost impossible.

Photographic news reportage in large halls, sports coverage of outdoor events, and the filming of stage presentations from third-balcony seats are three more examples of the types of situations that might call for the use of long lenses. Of course, the smaller image produced by a shorter tele can always be enlarged to a greater degree in the final print (which is the method used by many photographers), but more satisfying results are generally obtained when lenses of longer focal length are used to produce larger images right on the film.

As you might expect, all this power and optical reach is not without its price. It comes first in the form of extra cash you must shell out at the dealer; but it doesn't stop there. There are also the penalties of added weight, increased bulk, and smaller maximum apertures. The smaller apertures are necessary to keep the size and weight of the lens down, to minimize aberrations in this focal length, and to insure as much depth of field as possible when a lens of this size is used wide open.

Not inconsequential is the nuisance of carrying some of the longer optics. Because of their weight and size, they often need separate bulky carrying cases of their own. The result is that high-powered lenses are usually left at home unless there's a specific reason for toting them along. Many picture opportunities are lost when a photographer doesn't have a long lens at the right time.

Many other shots are missed even when a long lens is brought along and used, because the great magnifying

Longer focal length lenses are a joy to use at the bullring, the theater, or the beach.

power of such an optic exaggerates every little movement of a hand-held camera. A sturdy tripod is highly advisable for most shots taken with lenses in the 3-power to 10-power (3× to 10×) range, especially at anything less than a camera's top shutter speed. But, since sturdy tripods add even more weight and bulk to photographic equipment, they're often left at home at the very times long lenses aren't. The result is usually a predictable collection of large, but shaky, images.

However, if you're the kind of photographer who does use a tripod, you'll get a double bonus. Besides achieving sharper images due to lack of camera movement, you'll be able to use slower shutter speeds with safety, thus allowing you to stop down further and increase the shallow depth of field inherent in all long-focal-length lenses. But be sure to trip the shutter with a cable release, or your finger pushing the button may introduce the very motion you're trying so hard to avoid.

THE LONG, LONG LENSES

For a 35 mm camera owner, focal lengths up to 500 mm (10-power) offer all the reach ever needed for the vast majority of photographs. However, there are a few photographers who have use for the really big guns—from 500 mm to about 1200 mm (10× to 24×) in true long-focus or telephoto lenses, and up to about 5000 mm (100×) in telescope adaptations.

Why are such long focal lengths required? For the same reasons that apply to lenses in the 3× to 10× range, but for more extreme conditions. A creature in the wild may be so far away that only a huge lens can produce a large enough image. And from the press booth of a football stadium, only a really long optic can get a tight close-up of action on the field.

The problems of weight and bulk are inevitably increased along with focal length. Maximum apertures tend to become ever smaller as lenses lengthen. And prices can be astronomical.

99

Super-long lenses prove their worth when conditions don't allow you to come anywhere close to your subject.

Use a tripod? You bet! Trying to hold one of these monsters while taking a photograph is an athletic feat in itself. And even if you can support it without breaking your back, the picture won't be sharp anyway. Magnification is so great that your slightest motion will cause the image to gyrate wildly. A tripod is a tremendous help in just supporting the lens and taking the weight off your arms, but its steadiness also assists in lining up a shot and framing the highly magnified image. Then, as already mentioned, it immobilizes the lens and camera during exposure and enhances depth of field by allowing slower than top shutter speeds to be used.

Often, with a very long lens, even a sturdy tripod doesn't offer enough stability. Some photographers have devised alternatives such as the pentapod (a five-legged "tripod" which supports an ungainly lens at both ends) to overcome any shakiness. Others have resorted to beanbags or similar firm but flexible supports to offset vibration. Some have simply draped blankets or weighted straps over a lens mounted normally on a tripod to increase steadiness. There's no one "right" answer. Many methods work, or at least help to some degree.

In single-lens-reflex cameras, it's not so much the action of the shutter which causes vibration during exposure as it is the movement of the mirror. To overcome this problem, a few SLR cameras include a provision for locking up the mirror before exposure (which, unfortunately, also cuts off the viewfinder image). This ability to eliminate vibration caused by mirror action is very helpful when extra long lenses are used, provided the subject is the kind that will stay put from the time of framing and focusing, through the mirror lockup procedure, and until after the moment of exposure. Not all subjects are that cooperative.

Two other problems associated with very long lenses have nothing to do with the lenses themselves but with the way they're typically used—to shoot pictures at a considerable distance. The space in between a camera and a far-off subject is not empty. It contains a great quantity of air, and it's this air which is the source of the two problems—wavy images caused by turbulence, and overall bluishness caused by water vapor in the air

scattering ultraviolet light.

The condition of haze and bluishness (especially bad with color film) can be helped by avoiding humid days and doing photography only when the air is dry. But since this isn't always possible, the next best remedy is to use a UV (ultraviolet) or haze filter for all long-range shots. A UV filter won't eliminate the problem completely (and won't do any good at all in heavy haze); but since there's no increase in exposure required, many photographers leave a UV filter on a long lens at all times. In addition to its prime function, it offers physical protection to the exposed front element of an expensive optic.

Air turbulence is prevalent on sunny days when land surfaces are quickly heated and the warmed air above them rises rapidly. Heat waves are produced, causing distant images to appear as though they're shaking or waving, especially when viewed through binoculars or long lenses. The only remedy (and not a very effective one at that) is to shoot slightly up or down through the intervening air instead of horizontally through it. Or, better yet, try to avoid turbulent conditions altogether.

Some cameras have a provision for mirror lockup, which helps eliminate vibration in long lenses at the time of exposure. The result is usually crisper images. Normally this method is restricted to stationary subjects.

Long lenses often need haze filters, since they're so often used to photograph distant subjects.

MIRROR OPTICS AND TELESCOPES

Taking a cue from telescope technology, many of today's photographic lens manufacturers produce long-focal-length optics that use curved mirrors to replace most of the transparent glass elements, resulting in lenses that contain both reflecting (mirror) and refracting (glass) components. Light entering such a lens doubles back on itself twice, each time after reflecting off one of the two internal mirrors, thus folding and compressing the light path and eliminating the need for a large portion of the lens mount's physical length.

The result is a lens which is shorter, lighter, and easier to handle than an equivalent focal length in a true long-focus optic. Manufacture is very exacting, but the mirror design helps control some aberrations to a greater degree than found in most refractive (non-mirror) lenses.

However, there are some disadvantages. The most obvious one is that (because of the peculiarities of its construction) a mirror lens contains no diaphragm. It's built to operate at only one specific f stop. Therefore, except by using faster or slower film, the camera's shut-

ter is the only means by which to control exposure, although neutral density filters (which do nothing but cut down on light transmission) can be employed with fast films to bring extremely bright light levels down into a workable range.

To some photographers, another drawback is the way a mirror optic generates little doughnut shapes at out-of-focus points in the picture area. These tiny "doughnuts" reflect the form of one of the internal mirrors. The small circles can be charming or annoying, depending upon subject matter and personal taste.

Further, a mirror lens is generally delicate. Its components are easier to knock out of alignment than those of a refractive design. Otherwise, it behaves much like any other long-focal-length lens. Mirror optics are most prevalent in the 500 mm size. Maximum apertures are typically $f/8$. However, longer focal lengths are available, up to about 4000 mm, in which case the largest stop is likely to be $f/10$ or $f/11$. Focal lengths shorter than 500 mm or maximum apertures greater than $f/8$ are rare.

A mirror lens reveals its internal structure by the way it turns out-of-focus highlights into little "doughnuts."

All the long, long lenses are, in essence, telescopes to which camera bodies have been attached. In fact, many telescopes, monoculars, and spotting scopes designed for visual use only have been adapted for photographic purposes. Mirror optics are no exception. They were originally developed as telescopes but have since become popular with photographers for the reasons given above.

TELEPHOTO USES AND EFFECTS

The most obvious use for a long lens is to reach out and magnify the image of a distant scene. Almost all teles are acquired for that purpose. However, they're also convenient when close-ups of small nearby subjects are desired but the photographer doesn't wish to approach too closely, when tracking timid creatures like squirrels or birds. The near focusing limit of some long lenses is 30

Long lenses, with their shallow depth-of-field, also create a strangely flattened out or compressed image with an out-of-focus background that can enhance your subject.

feet or more, but with extension tubes it can be shortened considerably.

In addition to these more traditional applications, long lenses can be substituted for normal focal lengths in order to increase control over perspective and depth of field. At far distances, scenes can be made to appear close but strangely flattened out or compressed. At medium and near distances, selective focus can be conveniently accomplished even at small stops because depth of field is so shallow in the longer focal lengths. With a long lens, the world can be made to appear quite different from the normal human-eye viewpoint.

Another aspect of greatly reduced depth of field, and a most important one to remember, is that long lenses require a considerable amount of care and precision in focusing. Therefore, they're best used in conjunction with a reflex camera. The modern 35 mm SLR and a long lens make an exciting combination.

Long lenses do have their drawbacks. Weight, bulk, slow speed, and price become bigger problems as focal length increases. But if you have the money and the need (and the strength), there's nothing quite so photographically satisfying as gazing through a camera's viewfinder at the large, clear image of a far-distant subject.

Long lenses expand your "reach" and bring otherwise difficult subjects into practical shooting range.

6

The Wide-Angle Lens

As we've seen, a telephoto or long-focus lens (which can also be termed narrow-angle) takes in a smaller field of view than a normal optic, and thereby magnifies the subject. On the other side of the photographic coin, a wide-angle (short-focus) lens takes in more than normal and as a result renders the subject smaller. And, just as long lenses come in several sizes from moderate to extreme, wide-angles run a similar gamut from medium-wide to super-wide. Likewise, with both long and short lenses, the further from normal the focal length, the higher the price, the slower the speed, and the greater the care needed in taking pictures with them.

Telephotos are often used when a subject is too far away for the normal lens to produce a sufficiently large image from a given distance. Wide-angles are used for the opposite reason—when a subject is so big that all of it can't be included by the normal lens from the camera distance selected.

Then why not just back up until the subject is small enough to be pictured in its entirety? This is sometimes the best solution, but it's not always possible, for there may be a cliff or a lake or a wall behind you to block your movement. It's under such restrictive conditions that the wide-angle lens reigns supreme. Its greater angle of view takes in a larger chunk of the scenery than either normal or long lenses, allowing complete images from surprisingly close range. However, the shorter the distance from which a photographer has to shoot a sizable subject, the shorter the lens he must use; for the shorter

When a wall prevents you from moving back any farther, a wide-angle lens can still provide generous coverage of your subject.

the lens (within any particular film format), the wider its angle and the more territory it'll take in.

Try the technique for determining focal length required as described in the chapter on telephoto lenses (chapter 5). Suppose you estimate that your subject would fit the film format nicely if its image were just half as tall (or half as wide) as that produced by the normal optic. Then put on a lens of half the focal length. (For a 35 mm camera, this situation would call for a 24 mm or 28 mm lens rather than the normal 50 mm.) If only one third the subject height is needed, use a lens with one third the focal length (16 mm or 17 mm).

SHORT FOCUS OR RETROFOCUS?

Just as the telephoto design was developed to overcome some of the drawbacks of the true long-focus lens (see

chapter 5), the retrofocus wide-angle was introduced to solve a great problem plaguing the true wide-angle: enough back focus to permit its use with a reflex camera employing a swinging mirror. (*Back focus* is the term describing the distance between the rear surface of a lens and the film plane when focus is at infinity.)

Before the advent of the modern single-lens reflex (SLR) camera, a wide-angle lens could be positioned as close to the film plane as required to accommodate its short focal length. In a 35 mm camera using a rangefinder and separate viewfinder (rather than a mirror to allow focusing and viewing through the taking lens), back focus was no problem. If a short lens was needed, it could be screwed into the camera body as far as necessary to bring it into focus at infinity.

However, when the 35 mm SLR began gaining fans, they were frustrated by the fact that wide-angle lenses could not be used. Clearance was needed so that the mirror could swing up just before exposure. But since both mirror and wide-angle lens of the day had to occupy the same space within the camera body, one of them had to go. It was almost always the lens, although one or two camera makers provided a method for locking the mirror up and out of the way so that a wide-angle could be inserted farther into the camera body. But this meant that through-the-lens viewing and focusing with a wide-angle was out. A photographer either had to shoot blindly or use a supplementary viewfinder mounted atop the camera body.

Then some genius came up with the *retrofocus* wide-angle. By clever optical design, this kind of lens behaves in every way like a true wide-angle, but it has a longer back focus. Its focal length can be incredibly short and its angle of view super wide, but it will still operate in conjunction with an SLR's swinging mirror because it can be positioned far enough away from the film plane so that there's no interference.

The retrofocus wide-angle lens is sometimes referred to as a *reverse telephoto,* and the analogy is a good one. A telephoto lens is relatively short but performs like one of much greater physical length. The retrofocus wide-angle is relatively long (that is, has a larger back

focus) but performs just like a lens of shorter physical length positioned much closer to the film plane.

Today, practically all wide-angle lenses for SLR cameras are retrofocus designs. They have contributed enormously to the current popularity of the 35 mm SLR camera, enabling it to encompass focal lengths from the phenomenally short to the prodigiously long.

MEDIUM WIDE-ANGLES

For the 35 mm camera, a medium wide-angle is in the 28 mm-to-40 mm range. At one time, the 35 mm focal length was the most popular of this grouping, but 28 mm is now generally favored—one reason being that many photographers have adopted the 35 mm length as their "normal" lens, and so a shorter one (28 mm) is required for comparative wide-angle effects. The usefulness of a 35 mm lens as the normal optic is borne out by the fact that

Both landscape (opposite) and building interiors often benefit from the use of wider-than-normal lenses.

compact 35 mm cameras with non-interchangeable lenses often come equipped with this focal length.

Just as a medium telephoto is the most versatile of the long lenses, a medium wide-angle will come in handy more often than those of shorter focal length. Common subjects like street scenes, landscapes, groups of people, and room interiors can all benefit from the use of a medium wide-angle. Lenses of this moderately short focal length are usually faster and less expensive than wider optics—as well as having, stop for stop, more depth of field than the normal 50 mm lens. This latter characteristic may be used to advantage in two ways: 1) by shooting at the same aperture as with the normal lens

but obtaining more depth, or 2) by opening up to a larger stop while keeping depth the same. Either way, the medium wide-angle is a useful and versatile optic.

In large film formats (4 × 5 and up), medium wide-angles are often referred to as *wide-field* lenses—the term *wide-angle* being reserved for optics of even greater covering power.

SHORTER FOCAL LENGTHS

In recent years, advances in lens manufacture have made possible a large assortment of wide-angle lenses in the 21 mm-to-28 mm range. These short focal lengths were once considered to be rare and exotic birds, but they're now within reach of almost everyone. Though perhaps not as generally useful as the more moderate wide-angles, they are still less extreme than the super-wides and can therefore be used on a great many occasions.

As focal lengths become shorter, depth of field increases at any given *f* stop and camera-to-subject distance, providing this particular group of lenses with a decided advantage in situations where depth is important. Of course, the trade-off is that shorter focal lengths pose more optical problems for manufacturers, so maximum apertures tend to be smaller and price tags larger as angles widen. Camera handling gets to be more critical, too, in that the kind of distortion resulting from pointing the camera up, down, or at an oblique angle to a subject becomes progressively exaggerated as focal lengths shorten. Consequently, the need to keep your camera absolutely level increases, unless you are deliberately trying for an offbeat effect.

When the camera is held level and a subject is not approached too closely, pictures taken with a 21 mm or 24 mm lens will not appear essentially different from those using a 35 mm or even the normal 50 mm except in the angle of view. Therefore, these shorter lenses, if handled properly, can be used simply to increase the amount of coverage from any particular distance without

noticeably altering perspective or other types of distortion. However, if exaggerated effects are desired, they can be accomplished quite easily with lenses of these shorter focal lengths.

THE SUPER-WIDES

When focal lengths for the 35 mm camera get down into the 15 mm-20 mm range, lenses can only be referred to as super-wides. Other camera sizes have their wide-angles, too, but only the popular full-frame 35 mm camera has such relatively short focal lengths available—and so many to choose from.

In this strange and exciting territory, there's an overlapping between super-wide and fisheye lenses. Both kinds take in a very wide angle of view, it's true, but there's an important distinction. Super-wides, like all lenses for general photography, are rectilinear—which means they render straight lines in the subject as straight lines on the film. Fisheyes, on the other hand, do not correct for "barrel" distortion but let straight lines be-

A super-wide optic like a 17 mm rectilinear does strange but interesting things to ordinary subjects.

113

come increasingly curved (barrel-shaped) as they approach the edges of the picture. More about fisheye lenses later.

The rectilinear super-wides can be quite useful for applications beyond novelty effects. In very cramped quarters, they can save the day. A large building on a narrow street or an interior shot of a small room are two typical situations that come to mind. But group shots of people or sweeping landscapes can sometimes benefit from a super-wide, too.

Because of their very short focal lengths, super-wides possess enormous depth of field, especially at the smaller f/stops. For this reason, landscapes or scenes in which subject matter stretches from inches away to the far distance are quite impressive. There's rich detail front to back, and the effect is often breathtaking. Further, by moving in unusually close to part of a subject, or pointing the camera at an odd angle, or both, amusing, startling, or mind-wrenching images can be produced.

Super-wides are not for everyone. Careful handling is required or grotesque effects may pop up where they're not desired. And these short, short focal lengths tend to be rather expensive—especially in view of their limited use—although most of them are far more affordable than a typical lens in the long, long telephoto group.

FISHEYES

A fisheye lens is peculiar—and it produces peculiar pictures, which have, in turn, helped earn it its peculiar name. The image created by a fisheye lens is odd in two ways. First, it's a circle instead of the rectangle we're accustomed to; and second, straight lines within it are curiously bowed and bent.

Any lens throws a circular image. But ordinarily, because of a relatively long focal length, the circle is large and the film records only a rectangle from the middle of it. However, in the case of a typical fisheye lens, the focal length is so short (as little as 6 mm) that the entire circle appears within the boundaries of the film format.

114

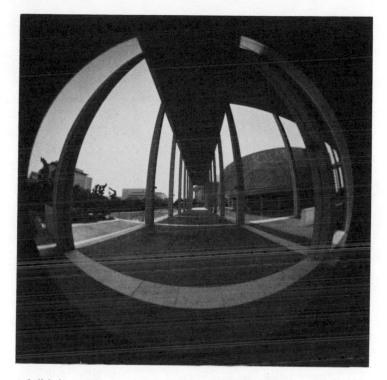

*A full fisheye lens presents a circular image, in which straight
lines curve more and more as they approach the outer edges of
the image.*

Furthermore, almost all lenses are corrected for as
many aberrations as possible. But not the fisheye. It's
deliberately uncorrected for barrel distortion, so straight
lines are bent more and more, from the center of the image
outward, until they match the circle's curvature at the
edges. The result is a wildly distorted circular image
displayed against a black background. The angle of view
is 180° or more, and a photographer has to be careful that
his own feet (or tripod legs) do not appear in the picture,
even when the camera is held perfectly level.

In longer focal lengths (up to 17 mm or so), fish-
eyes throw larger circles, so the final images are the
usual rectangular sections from the middle. However,

A semi-fisheye allows for a conventional rectangular image, but straight lines are still curiously distorted.

even though the full circular field is not apparent (and the angle of view is not as great), most of the curved and distorted lines are still visible, earning a lens of this focal length the term "semi-fisheye." Lenses in the 14 mm–17 mm range can be purchased either as rectilinears or fisheyes. But, although focal lengths may be identical, photographic results are vastly different.

Fisheye lenses are expensive, especially in the shorter focal lengths—or when they're designed for larger film formats. As indicated previously, this cost is even higher than it appears considering their limited use. But one or two lens manufacturers have provided some relief in this regard by supplying fisheyes as auxiliary optics, to be attached to the front of prime lenses (those complete in themselves) so that the combination produces the wide-angle fisheye effect. Such supplementary lenses are much less costly than prime fisheyes, although there are drawbacks in convenience and lens speed and, to some extent, in optical performance as well.

Fisheyes have few practical applications. It's true, they cover wider angles and take in more subject matter in a single gulp than any other type of optic, but the price for this great scope is bizarre distortion. Nonetheless, photos taken with fisheye lenses have arresting visual impact and novelty, and it's for this reason they're sometimes employed to make attention-getting pictures for use in advertising.

A FEW CAUTIONS

Wide-angles are helpful tools that can get you out of some tight photographic spots—literally. But you must handle them properly to avoid a few optical pitfalls. Here are some suggestions.

1) Keep your camera level. Any deviation from this will cause vertical lines to converge toward the top

Any lens can introduce an odd or amusing size relationship in a subject when used too close, but the wide-angle is especially prone to this type of perspective distortion.

of the picture if you point up, or toward the bottom if you point down. Of course, this effect takes place with any lens, but wide-angles exaggerate it. If you happen to want this kind of distortion, direct your camera sharply up or down. Deviating by only a few degrees from level will look like sloppy handling or careless oversight.

2) Watch your perspective. Since wide-angles are typically used close to a subject, picture elements tend to loom large in the foreground and to recede quite rapidly in the distance. Unless this is the effect you're after, be careful not to let a hand or a foot or anything else get too close to the lens. Always check the viewfinder with this in mind before tripping the shutter.

3) Check the viewfinder edges. Some wide-angles are really wide. Be sure not to get a finger or a cable release or a camera strap in the field of view. Ditto for the sun, unless you really want it there.

4) Give thought to focusing. Because short lenses have such great depth of field, even wide open, focusing is often difficult. The shorter the focal length and the smaller the f stop, the tougher it is. Instead of ignoring the problem and relying entirely on inherent depth, use the distance scale and the depth-of-field indicator on the lens mount. It's quick, it's convenient, and it eliminates the eyestrain and fuss of focusing visually with one of these midget marvels.

7

Zoom Lenses

The zoom lens is one of today's technological wonders. It was originally designed for 16 mm professional motion picture cameras in 1932. But because of the many complex optical problems to be solved in covering a larger film format, the first 35 mm still camera version didn't emerge until 1959. In the relatively short time since then, further technical advances have given the zoom not only increased compactness and versatility, but also performance characteristics approaching those of high-quality unifocal (single-focal-length) lenses. The result has been an exploding popularity among today's small-camera enthusiasts.

Just what is a zoom lens? Basically, it's one whose focal length, angle of view, and image magnification can be continuously varied within certain limits while accurate focus is maintained throughout the range. Beyond that, its description becomes complicated, for the modern zoom can incorporate many different approaches in its design.

PARFOCAL OR VARIFOCAL?

One of the choices a zoom lens purchaser has to make is between a *parfocal* design (which maintains its focus as magnification is changed) and a *varifocal* (which does everything a parfocal does but must be refocused after every shift in focal length). The choice seems obvious. The parfocal, or true zoom, is more convenient. Changes can be made more quickly, focusing can be done at the

119

longest setting before zooming back to the required length (thus insuring the most accurate focus), and slow-shutter-speed "zooming" effects can be easily accomplished.

But wait. That's not the whole story. By eliminating the many mechanical and optical complexities involved in maintaining focus throughout the zoom range, the varifocal can be made lighter and more compact, with greater maximum lens speed and closer focusing ability (without the use of a special "macro" range). And with all this, it will still probably deliver better optical performance and cost less.

Now the choice between the two types of variable-focal-length lenses is not as clear. But buyers seem to have arrived at a firm decision favoring the true zoom, since it outsells the varifocal by a very lopsided margin. Despite the number of gains to be realized in the varifocal, photographers have fallen in love with the convenience and glamour of the parfocal zoom.

But this doesn't have to be an "either/or" situation. Both lens types are important and should be considered by the photographers who want to expand their photographic horizons. However, for the balance of this chapter, it should be understood that the term *zoom lens* will refer only to the parfocal (true zoom) unless the varifocal is specifically mentioned.

SHORT, MEDIUM, OR LONG?

Another choice facing the zoom lens purchaser is the range of focal lengths. Do you need a wide-angle zoom (21–35 mm or 24–50 mm), a wide-angle-to-tele (28–85 mm or 35–105 mm), a moderate-to-medium tele (70–150 mm or 80–250 mm), or a super-tele zoom (100–500 mm or even 360–1200 mm)? These are just some representative focal lengths. Dozens of other combinations are available from several manufacturers. Some will fit only specific makes of cameras, but others can be attached to any camera that takes interchangeable lenses.

How do you determine which particular lens out of this astounding array will best suit your purposes? One

effective guide is not to duplicate any unifocal lenses you may already own. For example, if you now have (in addition to your normal 50 mm) an 85 mm and a 135 mm, it would seem a waste to buy a 70–150 mm zoom that includes these two focal lengths. A better choice might be a 200–500 mm or a 24–40 mm zoom, depending upon whether you have more use for teles or wide-angles in your picture taking. But if the moderate tele range is your prime concern, perhaps you should just add a 200 mm or 300 mm unifocal to what you already have and skip the zoom altogether.

Taking another approach, some photographers buy a zoom specifically to replace several unifocal lenses in order to reduce weight and bulk in their gadget bags. (Caution must be exercised here, for some zooms are pretty weighty and bulky all by themselves.) This doesn't imply that single-focal-length optics are then discarded. It just means that the zoom will be more convenient when traveling light is important.

Other photographers give low priority to considerations of weight, bulk, and presently owned lenses, buying a zoom solely to let them work more quickly and

A zoom lens can be used for almost any subject ordinarily covered with a fixed focal length. Here a zoom has been used for portraiture.

Zoom lenses, with their variable focal lengths, are very useful for nature photography since one lens can eliminate the need to carry many fixed focal-length lenses.

conveniently within the range of focal lengths they find most useful. Fast-action sports, nature, and child photography often demand rapid and frequent changes of magnification. A zoom covering the appropriate focal lengths is a great help. However, try to determine in advance that you really will take advantage of a zoom's full range. A 70–210 mm zoom used almost always at the 210 mm setting is a foolishly expensive alternative to a 200 mm unifocal.

HOW BIG A ZOOM RATIO?

After you've decided to buy a zoom within a general category (wide-angle, wide-to-short tele, or long-to-longer), you have a further option regarding the zoom ratio; that is, the ratio of the longest focal length to the shortest. For example, the zoom ratio of a 43–86 mm lens is 2:1, of a 70–210 mm is 3:1, and of a 100–500 mm is 5:1. A slight decrease in the shorter focal length of a zoom can expand a ratio significantly. An 80–240 mm lens has a 3:1 ratio, but if just 20 millimeters were chopped off the

short end, the resulting 60–240 mm lens would encompass a 4:1 difference.

Zoom ratios can be just as important as actual focal lengths. Most ratios are between 2:1 and 3:1, although as much as 6:1 has been done for still cameras. (In super-8 movie cameras, zoom ratios of 10:1 or more are not uncommon.) For sports coverage, a 70–350 mm zoom will provide a long 5:1 ratio, but if all a photographer needs is a "normal" lens with the ability to go wider or longer for better framing if a situation requires it, a 35–70 mm zoom with a modest 2:1 ratio will insure a lot of flexibility along with less bulk, length, and weight.

Besides, as a general rule, smaller ratios deliver better optical performance, especially in the shorter focal lengths. Therefore, if you want highest image quality, stay with the smaller ratios. However, if it's versatility you're after, go for the longer spans.

Today, it's possible to have most, if not all, your needed focal lengths wrapped up in just two zoom lenses. A 35–80 mm plus an 80–240 mm covers a lot of ground. If you need a short end that's even wider and don't mind a small gap in the middle of the range (where it will probably be least noticed), a 24–50 mm along with the above 80–240 mm will give you focal lengths with a whopping 10:1 ratio. Until a super-compact 20:1 dream lens comes along sometime in the future, this kind of combination is your best bet if your goal is to reduce the number of lenses you carry to a minimum.

STANDARD OR MACRO-FOCUSING?

One drawback of most zooms in the past has been their inability to focus as closely as unifocal lenses of comparable focal length—especially at the short end of the scale. But now, macro-focusing zooms have come to the rescue, and their burgeoning sales indicate their popularity among 35 mm camera owners. These newer lenses not only encompass all the normal zoom characteristics but have a lever or button or some other device which puts them into a special "macro" mode, allowing a photographer to focus on much closer subject matter.

Macro-focusing zooms provide for a much closer approach to some subjects.

Sometimes the term *macro zoom* is heard, but *macro-focusing zoom* is more appropriate, since most of these lenses don't really zoom in the macro mode. Instead, they behave like varifocals. That is, each time the focal length is changed in the macro mode, the lens must be refocused. Actually, few, if any, of these lenses should even be called macro-focusing, since they don't get you close enough to deserve that label. A more realistic term is *close-focusing*—one which some manufacturers have adopted.

In any event, whether called close-focusing or macro-focusing, these zooms should not be confused with single-focal-length true macro lenses, which (unlike general-purpose lenses) are designed to produce highest resolution at short lens-to-subject distances and are able to magnify subject matter to at least 1:2 (half life size) and often to 1:1. In addition, a unifocal macro has a flat field, which means that close-ups of stamps or pages in a book (if held flat) will be just as sharp at the edges as they are in the centers. Although a small number of close-focusing zooms having flat fields and best optical performance at close working distances are available, most zooms with macro ability are optimized for greater lens-to-subject distances and are best used on three-dimensional subjects, which don't require an absolutely flat field.

However, almost all close-focusing zooms have one advantage over unifocal macros in that exposure recalculation for close-ups is unnecessary. The zoom lens holds its *f* stop at any setting—including the macro mode. This may not be of much concern to the person with a through-the-lens metering automatic camera who

uses available light or floods. But for the photographer who uses flash (and whose camera doesn't meter that automatically, too), this feature can be a great help.

Close-focusing zooms do their jobs in various ways. Each manufacturer seems to have a different approach. While some lenses of this type will perform in the macro mode at any of the available focal length settings, most will do so only at the shortest end of the range (and are therefore less convenient). However, the compensation is that this second group will usually focus closer. Some short close-focusing zoom lenses at the widest setting will actually focus as close as (or closer than) a similar fixed-focal-length lens. A few will do so at any focal length setting.

When put into the macro mode, some lenses move forward as a whole for closer focusing (as though an automatic extension tube had been inserted). With others, front elements move or rear elements are repositioned to achieve the same objective. Sometimes (as with varifocals and ordinary fixed-focal-length lenses), there's no special macro range as such. Instead, focusing is continuous down to the closest available distance.

No one has yet claimed that the optical performance of a zoom in its macro setting equals that of a unifocal macro lens, but the differences are diminishing rapidly. And even though small stops are recommended for optimum results at close range, macro-focusing zooms provide a delightful convenience that overrides the minor drawbacks. However, because there are so many ways to achieve close focusing in these zooms, always ask questions and check out the handling and capabilities of any lens before you buy it. Get the one that will do the most for you.

OTHER CONSIDERATIONS

There are even more decisions to be made before you can be sure you have just the right zoom lens for your needs. For example, do you favor one-touch or two-touch controls? The one-touch system has a single control collar for both zooming and focusing. You push or pull on the collar to zoom in or out. Twisting it to the right or left

adjusts the focus. The two operations may be performed independently or at the same time, allowing for the kind of fast and flexible handling so important in action photography. However, the price for this simple control is greater mechanical complexity along with more bulk and weight. It's also easy to disturb either the zoom position or the focus setting as the other is being adjusted.

Although it's slower to manipulate, the two-touch system does offer some advantages. Since focusing and zooming are done by means of separate rings, the two functions must be dealt with individually—usually resulting in more precise settings. And because fewer complicated interior cams and sleeves are required in a two-touch lens, it's generally smaller and lighter than one with combined controls.

Either approach works well, but each has particular situations for which it's best suited. Analyze your needs and make your choice accordingly.

Another alternative is whether to acquire a fixed-mount or an interchangeable-mount lens. The first type is designed (usually by a camera manufacturer) to fit only one make of camera. But the interchangeable-mount variety (made by an independent lens manufacturer) will fit many different camera models, either directly or by the use of adaptors. If you have only one camera and intend to keep it for some time, the fixed-mount lens is ideal. But if you have more than one make of camera body or intend to buy another body with a dissimilar mount shortly, the interchangeable-mount lens is the obvious choice.

SPECIAL ZOOM EFFECTS

For some photographers, all the normal advantages of a zoom lens are not as intriguing as its ability to produce some very unusual effects. When zooming is done during a slow exposure (about one second or longer), startling and fascinating images result which can be obtained in no other way. Any subject seems to grow before your eyes. Stationary light sources explode and radiate in all directions. Moving lights twist, bend, or dance in unexpected ways. If the camera is also panned or otherwise

Zoom lenses are capable of certain special effects that are not possible with any other type of lens. Here the focal length of the lens was "zoomed" during a long exposure to blur the flames into streaks of light.

shifted in position while the zooming is taking place, even more effects can be generated. The end product is limited only by your imagination and willingness to experiment.

One necessary requirement in capturing such effects is a light level low enough to permit a slow shutter speed without overexposing the film. That's why nighttime pictures including artificial lights are so popular using this technique. Of course, neutral density or polarizing filters can be used to cut down on the light, but a nonfilter variation of the process can be employed even under the blazing sun (provided your subject is reasonably unmoving).

The idea is to take a series of increasingly magnified single shots on one frame of film (presuming you have a camera which allows accurate multiple exposures). For example, if you wish to expand a subject in a series of eight overlapping magnifications, first determine the basic exposure and then give each of the eight shots ⅛ of the total needed. Having the camera on a tripod during the entire series is almost mandatory.

A varifocal lens (which requires refocusing after each change of focal length) can easily be utilized for this multiple-imaging technique. A varifocal can even be used for a pure zooming effect if the subject matter is far enough away. Then the distance scale can be set at infinity and left there, eliminating the need to refocus as magnifications change.

PROS AND CONS

So far, we've looked at many different aspects of zoom lenses in order to better choose from among the large variety available. But should you really be considering a zoom lens purchase at all? To help you decide, let's now examine both the advantages and disadvantages of a zoom as compared with a typical lens of fixed focal length.

Zoom Advantages

1) From any given camera position, image size can be conveniently controlled without affecting perspective. Or, if a different perspective is desired, camera-to-subject distance can be varied and focal length subsequently adjusted to give the required image size.

2) Without altering camera position, images can be framed more accurately. This means of cropping in the finder for best composition is especially helpful with color slides.

3) Unlike the bother of changing unifocal lenses, various focal lengths can be reviewed easily—and in steps as small as you wish.

4) There are fewer lenses to carry. You can travel comparatively lightly (with only one camera body and one zoom lens) and still have great flexibility.

5) You can pay less attention to equipment and concentrate more on taking pictures.

6) You can be ready for many unexpected picture opportunities without fumbling for another lens.

7) You can follow action with image size constantly under control.

8) "Zooming" effects are possible by using slow or multiple exposures.

9) Some zooms are ideal for synchro-sunlight balanced flash photography. The actual distance from flash to subject is more or less fixed by the flash output, but the apparent distance can be easily adjusted with the zoom control.

10) Although a varifocal lens is not always as fast to bring into play as a true (parfocal) zoom, it's still much

faster (and considerably more convenient) than switching separate lenses.

Zoom Disadvantages

1) Zoom lenses are heavier and bulkier than any one of the unifocal optics they replace.

2) Purchase price is greater, often equaling that of two or three fixed-focal-length lenses.

3) Maximum apertures are smaller, usually $f/3.5$ to $f/4.5$, with $f/2.8$ being about tops. This means darker, harder-to-focus images in the viewfinder. In some zooms, because of the way they're designed, the aperture changes slightly with focal length shifts. This is no real problem with an aperture-priority automatic camera, but it may be a disadvantage with others. These lenses can be identified by the way their maximum apertures are marked—such as $f/2.8$–3.5 or $f/3.5$–4.5.

4) There's additional light loss over even the small rated maximum f stops because of reduced transmission through the necessarily large number of elements. Zooms are therefore much more useful outdoors (especially for action photography) than they are inside, where they're limited by their slow speed unless flash or studio-type lighting is employed.

5) Zooms do not focus as closely as unifocals except for some that have macro modes. And though these close-focusing lenses are even larger, heavier, and more expensive than regular zooms, they still don't match the optical performance of unifocal macro lenses.

6) A zoom (especially when it includes the wide-angle range) cannot be corrected as well for certain kinds of distortion as a unifocal lens. Negative (barrel) distortion, where straight lines near the edges of the image bow outward, are apparent at the widest setting. At the longest focal length, positive (pincushion) distortion bows straight lines inward. The greater the zoom ratio of a lens, the more evident these distortions tend to be.

7) Flare (light bouncing around inside the barrel and degrading the image) is more prevalent in zooms than in unifocals because there are so many glass elements. Lens hoods are not very effective in controlling

stray light from the outside because they have to be kept small enough to work at even the shortest focal length without cutting off (vignetting) part of the image.

8) Larger, heavier, and more expensive filters and other accessories are required for zoom lenses.

9) Zooms have more controls to manipulate than unifocal lenses, making it sometimes more difficult and confusing to grab an elusive shot before it gets away.

IN CONCLUSION

The modern zoom lens is a marvelously complex and useful tool. Designing one is a trying task at best, since it involves endless compromises, but computers are an enormous help. They allow many concepts to be explored and discarded before a real lens is actually constructed— and all at mind-boggling speed. With such savings of time and materials, rapid progress is inevitable.

However, all this progress would be merely a futile exercise in design techniques if it weren't for lens coating. With the large number of elements in a zoom lens, flare would rob the image of any practical usefulness if multicoating weren't employed to improve light transmission. But with its use, the zoom (which is more dependent upon multicoating than any other type of optic) has emerged as a modern miracle.

It's true that maximum speeds and zoom ratios have remained about the same over the years, but with the help of computers, multicoating, and new materials, image quality has so improved that the modern zoom has become a worthy rival to most fixed-focal-length lenses.

It seems highly unlikely that zoom lenses for larger format cameras will ever be practical because of size, weight, and cost considerations, but it's entirely possible that the average 35 mm camera of the future will sport nothing but a single zoom (perhaps attached permanently at the factory). Lens interchangeability may be completely unnecessary, because the one optic will be able to do almost everything.

8

Special-Purpose Lenses

Any lens can be thought of as "special-purpose" when it fulfills a photographic need better than other focal lengths or types. Medium wide-angles, medium telephotos, or even normal focal lengths can be regarded as somewhat special-purpose on those occasions when their particular focal lengths are just right for certain shots. However, these three types of lenses are so common and account for such a large percentage of all pictures taken that they're customarily considered to be quite ordinary. They don't qualify as special in the sense of being unusual.

When we move on to the very wide and super-wide-angles, long and superlong telephotos, and normal focal lengths with extremely large maximum apertures, we're unquestionably entering the realm of special-purpose optics. These lenses aren't used very often on the type of subject matter photographers encounter most of the time. Typically, they're hauled out only to cope with unusual situations.

But even these lenses are "ordinary" in their basic design. They differ from the very common ones only in the degree of their shortness, longness, or speed. They're not special-purpose in the same sense as lenses which incorporate novel design approaches in order to solve particular photographic problems.

The zoom used to be that kind of exotic lens, but it's now so commonplace that it hardly qualifies anymore. It's become almost general-purpose in its use. Therefore, we'll have to look a little farther for the unusual in special-purpose optics.

THE MACRO LENS

The first example that comes to mind is the single-focal-length macro lens. Although it's readily available, most photographers don't own one. This is not because close-ups aren't popular. It's just that there are so many ways of obtaining close-ups that an expensive macro lens is often the last choice. Most normal lenses focus quite close, and with the additional help afforded by close-up

A true macro lens makes close-up photography relatively simple. Careful lighting and close, sharp focus are well suited to glass.

lens accessories or extension tubes or bellows, they can get even closer. And now that a close-focusing mode is also part of many zoom lenses, there isn't a pressing need for most people to buy a special lens just to get close to a subject.

So the true macro lens remains unusual as well as special-purpose. With its remarkable ability to move in on a subject, to attain optimum performance at short lens-to-subject distances, and (because of its flat field) to deliver an image which is sharp from corner to corner, the macro can get you closer with less fussing and with better optical quality than any of the other devices which popularly replace it. Instead of being just a convenient subsidiary function of a general-purpose optic, the close-focusing ability of a macro lens is its prime feature.

THE BELLOWS LENS

The so-called bellows lens is another special-purpose optic which has the same flat field and close-focusing superiority of a macro. It's designed to be used in conjunction with a separate bellows because its simple mount has no focusing provision of its own and is too short to position the lens the proper distance from the film plane if attached directly to a camera. A bellows is needed between the lens and a camera body to make up for the short mount and to allow continuous focusing from infinity down into the macro range (often greater than full life size).

This bellows/lens combination was the best equipment available for close-up photography before the modern self-contained macro lens was introduced. It's still a very good choice—much better, for example, than using a camera's normal 50 mm optic on the end of a bellows. The normal lens will not focus at infinity because the bellows (even when folded up completely) is too thick to let the lens come close enough to the film plane. Also, the normal lens is designed to work best at far distances and doesn't have the flat field desirable for close-up work.

You may be wondering why anyone would use a bellows lens instead of a handier "macro". It's true that a short-mount lens attached to a bellows is not as sturdy as a macro, that it's more difficult to operate handheld, and that it often doesn't even have an automatic diaphragm. But it has one outstanding feature—reasonable price. Because it's simpler and cheaper to manufacture than a macro, a bellows lens will give you comparable optical quality at a fraction of the cost—especially if you already own a bellows assembly. In addition, short-mount lenses come in a larger variety of focal lengths than macros, allowing you considerably more scope in your choice of magnification and working distance.

THE MIRROR LENS

The subject of mirror lenses has already been covered in chapter 5, so a short review should be all that's necessary here.

Even though its special construction makes it unusual and earns it a place among special-purpose objectives, a mirror lens is simply another form of long-focus optic. It's distinguished by being shorter (but thicker) than other long-focus lenses because it contains two curved mirrors which bend the incoming light back on itself twice on its trip to the film. The mirrors not only permit a reduction in the length of the mount but also eliminate the need for most of the normal transparent glass elements.

The resulting package is shorter, lighter, and easier to handle (although more delicate) than any other type of lens with the same focal length. But maximum aperture is relatively small and is fixed at just one opening. No adjustable diaphragm can be built into this design, so changes in exposure are less convenient to make than with conventional telephotos. Shutter speeds, film speeds, and filters are the only controls available.

The typical mirror lens focal length is 500 mm, and the usual aperture is $f/8$. Prices are competitive with other lens types of comparable focal length and optical quality.

Although a mirror lens is prone to camera vibration, provides limited depth-of-field, and does strange things with out-of-focus backgrounds, it does put you delightfully close to "shy" subjects.

THE FISHEYE

The fisheye lens, like the mirror lens, was discussed in detail previously (see chapter 6), so we'll just hit the highlights here.

Because of its short focal length (as little as 6 mm), the true fisheye lens throws a circular image covering 180 degrees or more which is completely included within the film format, making it the ultimate in wide-angles. But because the lens is deliberately uncorrected for barrel distortion, all straight lines not on the axis are bent—progressing from slightly bowed near the center to wildly distorted along the circular edge of the image.

In fisheyes with longer focal lengths (up to 17 mm or so), all of the larger circular image cannot be included within the film area, so just a rectangular section from

the middle is recorded. However, the characteristic distortion of straight lines is still present, so these lenses are often referred to as "semi-fisheyes."

To help combat the expense of prime fisheye lenses, some manufacturers have developed auxiliary lenses which, when attached to the fronts of conventional optics, produce the wide-angle fisheye effect—from full circle to semi-fisheye, depending upon the focal length of the regular lens. Although cost is lowered by this means, so is convenience, lens speed, and optical performance.

Fisheye lenses require specialized subject matter in order to be effective. Casual shooting yields a high percentage of disappointing results, but care in choosing your subjects can create pictures with startling visual impact.

THE SOFT-FOCUS PORTRAIT LENS

From photography's very beginning in the early 1800's, cameras have been able to make portraits possessing a velvety softness that minimized lines and wrinkles and imparted a magic, romantic aura to a human subject. At first it was unavoidable; even the best lenses of the day contained so many defects (including spherical aberration) that really sharp images were impossible to achieve.

As time passed, lenses improved in quality and all aberrations were tamed to a considerable degree. But some lenses were produced which deliberately retained much of their spherical aberration. These special optics were for the portrait photographer, who knew that his subjects approved of the flattering softness such lenses allowed.

Until quite recently, soft-focus portrait lenses (containing a great deal of uncorrected spherical aberration) were designed only for large format studio-type cameras. But now, special portrait lenses are available for both medium format and 35 mm cameras.

Spherical aberration is a condition which causes light rays entering a lens away from its center to focus at

different points from those entering along its axis, the change being gradual from the center outward. That's why stopping down a portrait lens sharpens the image; it cuts out the peripheral rays and allows only the central ones to register. Therefore, using a soft-focus portrait lens wide open produces the greatest diffusion. Stopping it down gradually clears up the image until, at $f/8$ or thereabouts, everything is wire sharp.

Special-purpose portrait lenses are generally very well corrected for all aberrations except spherical, which is then controlled by the photographer. Other than simply stopping down, control devices include movable internal lens components, filters to block out certain parts of the light beam, or "sink-strainer" metal inserts to help produce various effects.

OTHER SPECIAL-PURPOSE OPTICS

Wherever there's an unfulfilled photographic need, some enterprising firm will try to plug the gap, often succeeding admirably. As we've just seen, many special-purpose lenses have been developed to cope with specific photographic situations. But there are still others which should be mentioned, even though they may not be as commonplace or generally useful to the majority of photographers as those already covered.

The Perspective-control Lens

This is a 35 mm-camera optic which mimics one of the features found on a view camera—the ability to shift the lens both vertically and horizontally in order to avoid certain distortions in the image. The complex lens mount can move the lens off-axis up to several degrees, with the results of the shift readily observable in the viewfinder. This optical versatility is valuable, for example, when a photographer wants to take in more of a tall building but less of the foreground without pointing the camera up and making vertical lines converge.

The Medical Lens

This highly specialized precision lens is intended primarily for medical and dental photography. It's a macro of generous focal length with built-in flash and automatic exposure compensation. Its relatively long focal length allows pictures from half-figure shots to life-size close-ups at a comfortable working distance, and its ring-shaped flash provides even, shadowless lighting—as well as exposures fast enough to prevent hand-held camera movement. It operates within a range of about ½ foot to 5 feet, so it's definitely not a general-purpose optic. However, nature photographers and others shooting close-ups regularly will find this lens very convenient—even if its substantial price may not be.

The Night Lens

Optics using electronic light intensification for shooting in the dark have previously been available only to military forces or law-enforcement agencies, but at least one "night" lens of this type can now be purchased by the public. It's a telephoto using fast mirror optics and a three-stage electronic image intensifier (with self-contained high-voltage supply and batteries) which produces a light gain of more than 2500 times when compared with an ordinary $f/1.4$ lens using the same film. Due to the intensifier, the image produced is a bright green, so only black-and-white film is practical. This lens is not seen at many camera club gatherings because of its very high price.

The Right-angle Lens

This is a type of lens which (unless closely examined) appears to be an ordinary medium telephoto. In operation, however, light (instead of coming in from the "front") enters through an inconspicuous opening in one

side, reflects off a front-surface mirror set at a 45-degree angle within the mount, and continues on through the lens elements to the film. By means of this arrangement, a photographer can seem to be taking pictures in one direction while actually shooting in another—at a right angle to his apparent line of sight. Photos of shy subjects are more easily obtained with this kind of optic.

The Auto-focusing Lens

The idea of lenses focusing themselves without human assistance used to be regarded as wildly improbable by most people. But today, several lenses which can do just that are being manufactured. However, they're presently intended only for specific cameras (both still and movie) and are generally not interchangeable.

These auto-focusing optics accomplish their magic by a variety of techniques, including the use of sound waves, infrared light, and contrast comparison. In all cases, accurate focus is achieved easily, and much more rapidly than by hand. But each method has trouble with at least one photographic condition or type of subject matter, so a manual setting that disengages the auto mode solves the occasional problem—and also allows for creative focusing under any conditions.

Most simple-to-operate nonprofessional cameras of the near future may rely heavily on some type of auto-focusing mechanism—used, perhaps, in conjunction with an all-purpose permanently mounted zoom lens.

Miscellaneous

Other special-purpose lenses that you will often encounter are those specifically designed to be used in enlargers or projectors (for both slides and movies). To a still photographer, motion-picture camera lenses as a group are also special-purpose in that they will function properly only with the small formats of movie film. And then

there are the lenses in microscopes, telescopes, binoculars, and monoculars—all of which are somewhat special even before being used in conjunction with a camera.

As a photographer, you can certainly get by very well and take thousands of successful pictures using only ordinary lens equipment. But if you are irresistibly attracted to one or two of these specialty optics—and can afford the price—you'll have fun, and your photographic horizons may expand enormously.

9

Lens Accessories

While the lenses we've been examining are quite impressive in themselves, their capabilities can be expanded through the use of accessories—filters, extension tubes, tele-extenders, lens hoods, etc. A detailed study of all these various devices would require a whole book. However, we can look at some of the most common ones briefly.

LENS HOODS

Probably the most useful lens accessory you can own is the simple lens hood or shade. It's light in weight, has no moving parts, and is rather durable. And if it should be damaged or lost, it costs little to replace. However, in return for your small investment in money and time to attach it, a lens hood will do the following things: 1) Keep stray light outside the picture area from bouncing around inside a lens and creating flare; 2) Protect a lens by absorbing some of the jolts and knocks a camera often receives when in use; 3) Help keep snow, rain, sand, and fingers from the front element of a lens; 4) Hold filters and other optical accessories in place.

Many lenses (especially long teles) come from the factory with hoods built in, but others require hoods to be screwed into or slipped over the front of the mount. Some hoods are made of thin stiff metal (painted black to minimize reflections), while many newer ones are formed from soft black rubber and fold back out of the way when not in use.

A bellows-type hood is an even more effective controller of extraneous light, for its length is adjustable.

Its black, pleated bellows rides on rails, and its open front locks in place wherever necessary to block out as much unwanted light as possible without cutting in on the angle of view of any particular lens. A bellows hood is much more expensive than a simple hood, and it's heavier and clumsier as well, but it does an outstanding job of shielding the lens. It will also hold a large variety of gelatin filters and cut-out masks in place, making it a versatile assistant for the really serious photographer.

A lens hood is always in there working for you. A camera is not fully dressed without one.

EXTENSION TUBES AND BELLOWS

If your camera can handle interchangeable lenses, it can make use of a set of extension tubes or a bellows unit between a lens and the camera body. Positioning a lens farther from the film plane allows it to focus much closer. Therefore, extreme close-ups can be made without resorting to a special macro lens or a close-focusing zoom.

Extension tubes usually come in sets of three, each one a different length. They can be used individually or combined in various ways to obtain a total length which comes closest to your requirements. The least expensive sets are completely manual, meaning you lose the automatic diaphragm function of your lens—others contain linkage which retains most or all auto features.

A bellows unit is more versatile (and more costly) than a set of tubes, for it can be extended to exactly the right length at any point between its near and far limits. There's no trial-and-error searching for the correct combination of tubes to produce the proper amount of lens extension.

Some bellows are rather elaborate, having two sets of double tracks instead of only one (so that fine adjustments of the entire camera position can be made as well as just that of the lens) and contacts which allow a lens to retain all its automatic functions. Used with a camera's normal lens, a bellows will permit accurate focus on any subject from fractions of an inch to several

Extension tubes economically convert ordinary lenses into macro lenses with excellent results.

feet away. With a suitable "short-mount" lens, this distance may be extended all the way to infinity.

CLOSE-UP ATTACHMENTS

For a less complicated approach to close-ups, involving minimum cost and minimum gadgetry, nothing can beat the simple close-up attachment. It's just a single, positive glass element that screws onto the front of a lens mount like a filter and shortens the focal length of any lens, thereby allowing closer focusing than a prime lens is capable of by itself.

This accessory comes in several sizes (series numbers or diameters) as well as in several different strengths or powers (such as +1, +2, +3, etc.). The larger the number, the shorter the focal length and the greater the ability to take close-ups. However, each power works only within

a limited range of distances, so several attachments may be needed to cover all your requirements. Powers may be combined to obtain greater strengths (for example, a +2 with a +4 equals a +6), although using more than two at a time can result in poor image quality and may vignette the picture area (cut off corners).

Close-up attachments cannot provide the corner-to-corner wire-sharp images attainable with a macro lens (or even an ordinary lens used with extension tubes or a bellows unit), but they're more than adequate if the prime lens is stopped down at least half way. This is no particular hardship, since depth of field is very shallow in close-up picture-taking anyway (sometimes as little as a fraction of an inch) and small stops have to be utilized to gain as much depth as possible.

If you use a camera with ground-glass focusing (such as a 35 mm single-lens-reflex) behind a close-up attachment, framing a subject and determining sharpness and depth of field are comparatively easy, especially if you have plenty of light. But if you use a nonreflex camera and can't look through the lens, you'll have to take very careful measurements. Tables of distances, power combinations, fields of coverage, etc. are included when you buy a close-up attachment.

Simple accessory lenses come in negative powers (-1, -2, -3, etc.) as well as positive ones. A negative lens, when attached to a regular optic, causes the focal length to increase, giving a telephoto effect. However, the positive accessory lenses (for close-ups) are much more popular.

Besides the low cost, light weight, and simplicity of both positive and negative lens attachments, there's the advantage of not having to worry about exposure compensation. If your camera does not have automatic exposure capabilities and you're using extension tubes or a bellows unit for close-ups, the mathematics can get pretty tedious. However, with simple lens attachments, exposure is not affected, so it causes no additional problems. If you're just becoming interested in capturing large images of small things, buying a close-up attachment or two is a good way to start.

A tele-converter will make your ordinary lens behave as if it had doubled or tripled its focal length. This is a very practical way of inexpensively extending the range of your lens system, especially when it's safer to keep your distance.

CONVERTERS AND EXTENDERS

Lens accessories known as converters or extenders are small lens systems in themselves. The best-known are the tele-converters (also called tele-extenders). When mounted between a lens and a camera, a tele-converter increases the focal length of the prime lens and provides higher subject magnification. The two-power (2×) extender is very popular, although 1½×, 3×, and zoom extenders are also available. An extender/converter is more complex than a simple negative lens attachment; consequently, it delivers better image quality.

One type of converter is tailored to match the requirements and characteristics of a specific lens or lens system. It does a fine job of increasing focal length without degrading the image. Other converters are general-purpose and will work with many different lenses. Some brands are available in several mounts to fit various cameras. Since their design has to be a compromise, they don't offer quite the same high image quality as an extender intended for one lens only. For many applications, however, they're ideal—small, lightweight, inexpensive, and a lot easier to carry around than an additional prime lens. For example, by using a 2× tele-converter with a 135 mm lens, you get a 270 mm tele for no more than the small additional price, weight, and bulk of the converter alone.

There's another type of auxiliary lens system which converts an ordinary lens into a fisheye complete

145

with the characteristic short focal length and pronounced barrel distortion. The converter is much less expensive than a prime fisheye and serves well for occasional use.

A further use for extenders is to increase close-up rather than telephoto or wide-angle power. As a means of providing flexibility in use, some makers of macro lenses offer their product in two sections. The first is a prime lens which can function very well all by itself down to a distance producing a half-life-size image. The second section is a carefully matched extender (which can be purchased later if needed) that increases magnification to full life size or more and completes a unified lens system. However, even if a photographer has acquired the extender, it needn't be attached to the prime lens all the time. If extreme close-ups aren't the goal on a particular occasion, leave the extender at home or in the gadget bag—thereby reducing the size and weight of the lens on the camera.

Sometimes, when a camera doesn't have interchangeable-lens capability, the manufacturer will furnish accessory converters that moderately increase or decrease the focal length of the fixed lens. The resulting telephoto or wide-angle combinations are helpful and quite adequate for many situations, affording much better image quality than that obtainable with simple positive or negative lens attachments.

Unfortunately, all converters or extenders reduce to some degree the amount of light reaching the film. In effect, they decrease the speed of a prime lens. However, this is usually not a serious drawback (especially outdoors) and shouldn't discourage anyone from using these very handy accessories.

FILTERS

There's a great deal of mystery and confusion among many photographers concerning the use of filters. What good are they? Why use them at all? Which ones are "best"?

Filters change the color balance of light reaching

the film in a camera, so they can be used to alter the relationship between various tones in black-and-white film or the hues of color materials. Tones or colors can be "corrected" to more closely resemble what the human eye sees, or they can be deliberately thrown out of balance to produce interesting, picturesque, or even bizarre effects.

All filters act by holding back (absorbing) some of the light or other radiation headed for the film. Therefore, their use generally requires an increase in exposure, the amount depending upon just how much light is absorbed and its color. The speed of the film being used and its sensitivity to various colors is also an important consideration.

The necessary exposure increases are known as *filter factors*. For example, a 2× factor means that the exposure must be doubled, either by opening up the lens one stop or cutting the shutter speed in half. Filter manufacturers provide factors that are reasonably accurate, but you may have to experiment a little to find the exact increases needed to match your own particular equipment and artistic tastes.

Gelatin squares offer the largest variety of colors in photographic filters; and though relatively inexpensive to buy, they're optically superb. However, they're easily scratched or finger-marked and must be handled with extreme care. Gelatin filters cannot be screwed into a lens mount like other types, so they're placed in special holders or bellows-type lens hoods.

To make a gelatin filter more durable, it's sometimes mounted between clear, perfectly flat pieces of photographic-quality glass. Often, this glass "sandwich" is then enclosed in a metal ring having flanges or screw threads for easy attachment to a lens mount.

Although high-quality hard plastic is sometimes used, the best and most expensive filters are made by mass-coloring special glass and then grinding and polishing it to the same degree of accuracy employed in making lenses. This guarantees that the filter will do nothing to change the quality of the image formed by the camera's lens except to alter some color relationships. High-quality, solid-glass filters are coated like lenses and mounted in metal rings for convenience.

Photographic filters fall into a number of groups according to their particular use, but their use covers such a broad range that entire books have been devoted to the subject. Here we can only point out some of the general types and encourage further reading on the subject. Always bear in mind that some filters fit into more than one category and that unorthodox uses can be fun and rewarding.

Ultraviolet-Absorbing Filters

These filters are often used by photographers who forego other types. They hold back ultraviolet light, to which most films (both color and black-and-white) are overly sensitive. Their use can eliminate much of the blue cast found in color shots taken of distant views, or across bodies of water, or on overcast days. Some ultraviolet-absorbing (UV) filters are clear and are marked simply "UV." Others are a pale salmon color and are known as skylight filters. Both UV and skylight filters are frequently left on the camera for all outdoor shots, since they don't affect exposure but *do* protect expensive lenses.

Haze Filters

The haze filter is a first cousin to the UV, for they both do about the same job—absorb ultraviolet light. However, UV and skylight filters are intended primarily for color film (since they have no strong effect on color balance), while the haze filter is a shade of yellow, absorbs some blue light along with the ultraviolet, and is meant for black-and-white photography. Of course, the UV and skylight filters can be used for mild improvement in black-and-white photos, but for greater penetration of atmospheric haze, yellow, orange, or red filters (usually intended for other purposes) are more effective.

Color-Conversion Filters

If you should have a roll of color film in your camera that's balanced for indoor flood lights but you'd like to take some shots outside, you need a conversion filter. An

amber-colored filter made for that purpose holds back most of the outdoor blue light and lets through the reds and yellows, which is just what the indoor film "sees" as being natural. A blue filter made to do the opposite —convert daylight film to indoor use—sacrifices much of the film's speed and is recommended only for emergencies.

Light-Balancing Filters

These are like the color-conversion filters but much paler. With color film, their primary use is to make small corrections in color balance between closely related light sources, such as from photofloods to clear flash bulbs, or from clear flash to quartz floods. Some of the "warm" light balancing filters can also impart a more natural look to an overly blue daylight scene, while the bluish ones can help tame the excessive reds and yellows occurring in the early morning or late afternoon hours.

Correction Filters

Black-and-white film does not respond to colors in the same way as the human eye. Blues register too heavily, making blue skies and blue eyes appear light and washed

Certain subjects benefit from the use of contrast filters. They can be made to stand out beautifully when the sky has been darkened with the use of these filters.

out. A medium-yellow filter holds back some of the blue and brings outdoor scenes back into line, rendering them with about the same tonal balance seen by the eye. White clouds can be made to stand out from a darker sky instead of getting lost against an equally light background. A yellow-green filter will do the same job and lighten green foliage as well. It's also valuable for correcting a black-and-white film's overresponse to the rich reds contained in photoflood lights. Other filter colors act to correct other films and conditions.

Contrast-Control Filters

Sometimes a subject taken in black-and-white fails to stand out against its background. Even though subject and background are of different colors, they reproduce as similar shades of gray. This is a situation calling for a contrast filter. A red rose photographed against green leaves could get lost unless an orange or redish filter were used to let more of the rose through to the film and less of the leaves—resulting in a light flower against a dark background. A dark-green filter would have the opposite effect on the contrast. It would transmit mostly green light, rendering the leaves very light and the rose almost black. Either way, the contrast would be altered so that important picture elements are separated.

Polarizing Filters

Polarizing filters are different from all others in the way they operate. They don't hold back any particular color but instead block off light which has been polarized. Such light appears in nature at a 90-degree angle to the sun, or from light reflecting off nonmetalic objects at a 30-degree angle. By rotating a polarizing filter a quarter turn in its mount, you can gradually go from a position of letting all polarized light through to one of cutting it off almost completely. In its maximum blocking position, the filter will render clear skies at a 90-degree angle from the sun as very dark, whether in black-and-white or color. This filter is, therefore, extremely useful with color film, because it darkens or subdues selected parts

of a scene without altering color balance. With black-and-white, an orange or red filter added to a polarizer will render a sky black, so that clouds stand out starkly.

Neutral-Density Filters

Sometimes a filter is needed that will absorb light of all colors equally. Neutral-density (ND) filters do this. As a consequence, they reduce light intensity without upsetting color balance in any way, making them suitable for use with color films as well as black-and-white films. They come in various densities and can be combined to produce stronger ones. A typical use might be in conjunction with taking an outdoor portrait in bright light. You want a large aperture in order to throw an unsightly background out of focus, but the shutter speeds available are not fast enough to prevent overexposure of the film. The ND filter comes to the rescue, knocking down the light intensity even though a large f stop is used.

Special-Effects Filters

There are several kinds of filters used solely to produce eye-catching and startling effects. Most are designed for color photography, but others are useful with black-and-white, too.

Some of these specialty items incorporate a polarizer along with a color filter to make available a whole range of shifting hues at the whim of the user. Some impose variously shaped patterns of prismatic colors on the scene you photograph. Others simply suffuse the entire image with a vibrant or unusual color cast. New variations and combinations are being developed constantly.

Certain other specialty items are used somewhat like filters, but they don't alter color patterns or balance. Instead, they manipulate the actual image in interesting ways. Multifaceted prisms duplicate an image two, three, four, or more times on one frame of film. The prisms can be arranged side by side, in a circle, or several other ways. There's also a type of attachment which renders bright points of light as starlike images. Another combines half a close-up attachment with clear glass so that

151

both near and far objects can be sharply focused in the same photo. The list goes on and on.

No attempt has been made to cover all the filters available for the dozens of known photographic applications nor to give specific names and numbers to even the filters and attachments we've been discussing. Each manufacturer has his own identification system, so you'll have to do a little investigating on your own to find the specific item you want. Visit camera stores, examine catalogs, and read books on filters and lens attachments. Buy a few that appeal to you and use them. You'll have fun and improve your photographic knowledge and skills at the same time.

ADAPTERS

Most of the lens accessories we've studied in this chapter attach directly to a camera body or a lens. They're made to be as compatible as possible. However, some accessories are unusual, or aren't primarily intended for photographic use, or are designed for a lens or mount of a different size. These are conditions that call for adapters.

There are simple adapters known as retaining rings which hold nonthreaded filters and other accessories in place when a lens hood isn't performing that function. There are adapter rings that allow a lens to accept filters of more than one size. And there are adapters that permit a lens to be used in a reverse position for better performance in close-up work.

Other kinds of adapters make it possible for a camera to be attached to a telescope or a microscope, or hold a slide-duplicating device in the proper position for copying. Both bellows-type lens hoods and bellows units for close-ups sometimes require special adapters. And some tele lenses can be used off the camera as telescopes with the help of special adapters and eyepieces.

Adapters come in many forms and may connect many unlikely pieces of apparatus. The whole photographic process benefits from their use. If you have an accessory that doesn't seem to fit your camera or lenses, don't despair. There may be an adapter out there somewhere just waiting to join you and your equipment.

10

Lens Handling and Care

No matter how expensive and well made a lens may be, improper handling and poor maintenance will degrade its performance.

Any lens is sharpest when it's held rock steady and the focus is perfect. Though we can't always achieve these desirable conditions, we should try for them whenever possible. Hand-holding a camera is convenient, and frequently necessary. But even with high shutter speeds, steadiness is often less than ideal, resulting in slightly fuzzy images. Taking a steady stance (or leaning against something solid), holding your breath, and slowly squeezing the shutter release like the trigger of a rifle helps a lot. Putting the camera on a unipod is even better. But using a tripod, especially a sturdy one, is best of all.

With the lens firmly supported, we can turn our attention to the subject. It may be moving, which could cause a loss of sharpness no matter how steady the lens is. A fast shutter speed may be enough to "freeze" it. If not, then smoothly panning the camera to follow its action as the shutter is tripped will frequently sharpen the image (although the background may now be blurred instead).

Learning to focus accurately every time takes some practice. The lens should be wide open (as it is between exposures on most cameras) in order to obtain the brightest viewfinder image and the shallowest depth of field. Both conditions make focusing easier. Focusing aids such as split-image or microprism rangefinders are a further help. The focusing ring should be turned until the viewfinder image becomes crisp, and then rocked

back and forth until there's no doubt that the very sharpest point has been located.

All this presumes you have time to be precise and careful. If you don't, use the smallest ƒ stops you can manage. Focus quickly (or preselect a zone using the depth-of-field scale) and take your shot. An imperfect exposure is usually better than no exposure at all. You may be lucky and bag a crisp winner in the face of adversity. If not, the "blurred hangover" school of photography is still rampant in some quarters. But if you want the utmost from your lenses, give them every chance to work for you.

In addition to handling lenses properly when actually taking pictures, you must treat them with care and respect between shots as well. Optical glass is delicate and relatively soft, so do everything possible to protect a lens (especially the front and back surfaces) at all times.

There are obvious dangers to avoid, such as dropping a lens on a hard surface, banging it against a rock while hiking, dunking it in a pool, or using it to ward off the elements in a sandstorm. Any of these conditions could turn a good lens into an expensive piece of junk. But there are safeguards which can reduce the chances of such calamities happening.

Carry your camera and its lens in a sturdy, foam-padded case when you're not shooting pictures. A good case will protect against rain, snow, blowing dust and sand, scratches, fingerprints, and sudden jolts—as well as the screw-loosening vibration caused by such a common event as traveling in a car.

When your camera is out of its sheltering case and you're in the process of taking hand-held pictures, make sure a strong, securely attached neckstrap supports it. Protect the lens with a skylight or ultraviolet filter along with a lens hood. And put a lens cap on if there are long pauses between exposures.

Many modern optics have front or rear elements which bulge out beyond the ends of the mount. Great care must be taken not to scratch the glass when such lenses are being interchanged with others. Both front and rear lens caps should be in place before any lens is set down or

put away, but these especially vulnerable optics deserve extra consideration.

Bumps and hard knocks are not the only dangers threatening the smooth and efficient operation of a good lens. Excessive "muscle" in manipulating the rings and levers of a lens mount can cause just as much damage. Never force anything. Be gentle. If a lever or button or switch won't budge or otherwise move with its accustomed smoothness, stop and THINK. Is there some safety interlock operating that you've forgotten about?

If you've checked to make sure everything has been handled properly, but the control is still balky, go back to the owner's manual and see if there's a standard procedure for clearing up just such a jam. If that strategy fails as well, take your problem to a competent camera repair shop. If you had forced something, you'd probably have ended up there anyway—but with a lot bigger tab.

Although you may handle your lenses with great care and protect them from the perils of the environment, sooner or later they're going to need cleaning. You may have prevented everything but the air itself from touching the glass, but even the air can slowly deposit a thin layer of greasy, image-degrading residue on lens surfaces. Fingerprints, grease smudges, or salt water deposits make the situation that much worse. Besides further reducing lens sharpness and contrast, they can permanently etch the soft optical glass.

In cleaning a lens, the idea is to do it no more often than absolutely necessary and to avoid damaging the delicate, coated surfaces in the process. It's much better to prevent surface accumulations than to clean them off. Constant wiping may do away with dust and an occasional fingerprint, but it may also do away with some of the antireflection coating and scratch the glass as well, lowering the ability of a lens to produce a sharp image with good contrast.

When, at last, you must clean a lens, certain procedures should be followed. No matter what kind of dirt is smeared on the glass, get rid of any dust first. Dust particles can act as tiny chisels and scratch the lens if they're not removed before any wiping with a lens tissue

begins. If possible, blow off all the dust with a syringe or a can of compressed air. If this method fails to remove it completely, try the gentle application of a *clean*, good quality brush. Start on the outside and, using circular strokes, work toward the center. Cheap art brushes may contain oils which can compound your cleaning job, but a good sable brush or one designed specifically for photographic lenses can be used with safety, *if it's kept clean*. Even a good brush may sometimes accumulate dirt and grease, transferring it to a lens surface. To prevent this happening, wash it occasionally with warm water and mild soap. Then let it dry thoroughly before using it again.

After dust has been removed from a lens, you can proceed to tackle the more stubborn deposits. A loosely wadded lens tissue should be used to wipe the surface in a circular motion—again, from the outside into the center. Use very gentle pressure to prevent scratches.

If this treatment still isn't enough, try breathing on the lens with a wide-open mouth. A small amount of moisture will condense on the lens and help in picking up dirt and grease when another lens tissue is applied. If you're still unsuccessful, take a fresh lens tissue, make a loose wad, and put a drop or two of lens-cleaning fluid on it before wiping the lens again. Gently pick up excess moisture with a dry tissue.

Never put lens-cleaning fluid directly onto a lens. It may run down under the edges of the mount and damage the cement holding the elements together, or dry on an inner lens surface and be impossible to remove without a major repair job. Even when the fluid is applied by tissue, don't use too much.

A further warning. Use only photographic lens tissue, not cleaning tissue designed for eyeglasses. The latter is usually silicone treated and will scratch lens coatings.

The grooves and flanges of a lens mount need cleaning periodically, as do the glass surfaces. Compressed air usually does a good job, although a slightly dampened cloth may be needed to remove stubborn accumulations of grease or dirt.

Zoos are dusty places and it's important to remember that clean lenses that are free from dust are vital to clear photography.

Again, it's much better to keep a lens protected in the first place than to have a big cleaning chore later. Lenses are fine, precision instruments, but somewhat delicate and fragile. Treat them well and they'll reward you with many years of good service.

Index